Brazil Futebol
Football to the Rhythm of the Samba Beat

Happy Birthday Ronaldo

Hope you enjoy the vibes
of the World Cup.

When I rejoin the
leisure centre
we could play
some badminton or
squash.

Yours, Wole.

First published by Carlton Books Ltd in 2014

Copyright © Carlton Books Ltd 2014

Carlton Books Limited
20 Mortimer Street
London W1T 3JW
www.carltonbooks.co.uk

A CIP catalogue record for this book is available
from the British Library

ISBN: 978-1-78097-399-9

Senior Editor: Conor Kilgallon
Art Direction: Darren Jordan
Design: Ben Ruocco
Picture Research: Paul Langan
Production: Maria Petalidou

Printed in China

Brazil Futebol

Football to the Rhythm of the Samba Beat

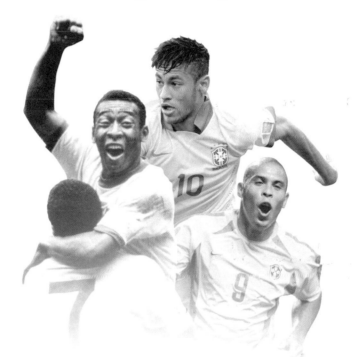

Keir Radnedge

CARLTON
BOOKS

Contents

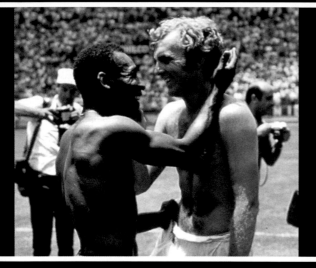
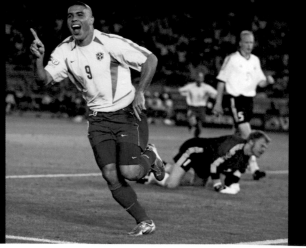

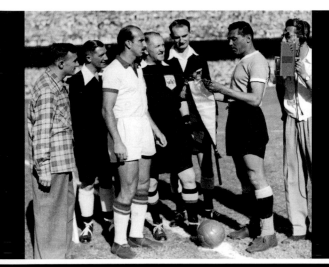

Introduction

FIFA president Sepp Blatter has a practised twist of phrase when he talks about the 20th World Cup finals. "The host country," he begins, then corrects himself: "But this is not so much a country, Brazil really is a continent."

So it is: 2,730 miles top to bottom, a unique country, a unique nation and a unique host. Brazil *is* the World Cup. The *Selecao* are the only national team who can boast a presence every finals tournament; the only one who can boast five victories; the only one whose never-ending flood of talent engages and entrances not only their own *torcida* but lovers of football all around the world. Other nations may be admired and respected for the varied qualities and styles of their interpretation of football, but the Beautiful Game is identified with only Brazil.

The World Cup is the greatest sports event on the planet. Nothing else draws so many eyes from every country, city, town, village and hamlet around the world. This is remarkable considering that "only" 32 national teams are competing for the crock of gold at the end of this sporting rainbow.

Perhaps this is the awful fascination. At the end of four weeks there can be only one winning team. The World Cup does not hand out a shower of medals day by day. Certainly there are winners all along the way, but those victories are only qualified and the ecstatic relief at not being on the plane home is only temporary.

The dream of a World Cup was turned into reality by Jules Rimet and C.A.W. Hirschman. They embraced progress with the advent of professionalism for the first time in 1930, while other sports stood still. Before long, football's sporting primacy was beyond challenge.

Uruguay hosted the first World Cup. Since then the finals have returned to South America on a further three occasions only, in 1950, 1962 and 1978. Until now. Brazil have a spectre to exorcise from 1950. Their defeat by southern neighbours Uruguay in the final match in front of a disbelieving 200,000 in Maracana remains a sore for the entire nation, including those not even born then.

Hence the story of football in Brazil is not merely about the game pioneered by Charles Miller in Sao Paulo and Oscar Cox in Rio de Janeiro. This is a story about the growth of a country, and its people coming to terms with the inescapable extremes of both development and social conflict. It's a story "written" with a ball, from the gloom of the favelas to the grass of Maracana. A partner in creativity and joy to the samba; a religion possessed of all the fervour and ritual of macumba.

This is Brazilian *futebol*.

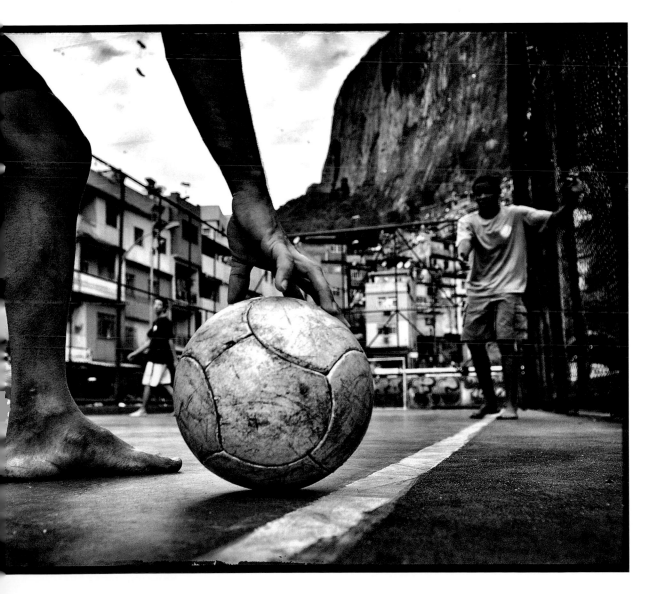

Chapter 1
BEGINNINGS

April 14, 1895, was not the first time anyone had kicked a football in Brazil. But the date is enshrined as the one on which the first organized game was played. The Sao Paulo Railway Company defeated the Gas Company by four goals to two. That was just as it should be. After all, it was a Railway man who was in charge of both the ball and the laws of the game.

Charles Miller, a Scottish railway engineer and keen footballer, is popularly credited with having imported the game of association football to Brazil. This is to over-estimate his role. A ball had been kicked around, in one odd form or another, up in Rio de Janeiro and in the ports. Miller, however, knew how to play the game "properly", which meant that he favoured "dribbling" and considered "passing" to be boring.

Ripples from that first match spread far and wide and fast. Miller and his friends persuaded the Sao Paulo Athletic Club, created in 1888 for cricket, to set up a football team. Miller, of course, was the team's first captain and centre-forward.

Meanwhile another son of the expatriate community was launching the football revolution in Rio de Janeiro.

Oscar Cox had learned the game during his school days in Lausanne, Switzerland. His father had been a founder of the Rio Cricket and Athletic Association. But young Oscar and his new game won friends at the Paysandu Cricket Club. On December 22, 1901, they played a first football match against Rio Cricket.

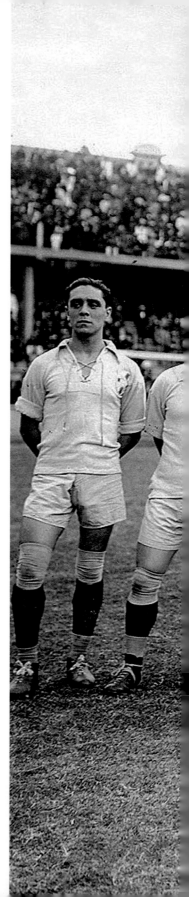

RIGHT: Brazil, hosts and winners of the South American championship in 1922. Five nations took part in a mini-league in Fluminense's Estadio Laranjeiras in Rio de Janeiro. Brazil, Paraguay and Uruguay all finished level on points and goal difference, so a play-off series was ordered by the South American confederation. Uruguay, who had scored the most goals, went home in protest, and Brazil won the title for the second time by defeating Paraguay 3–0 through goals from Nito and Formiga (two).

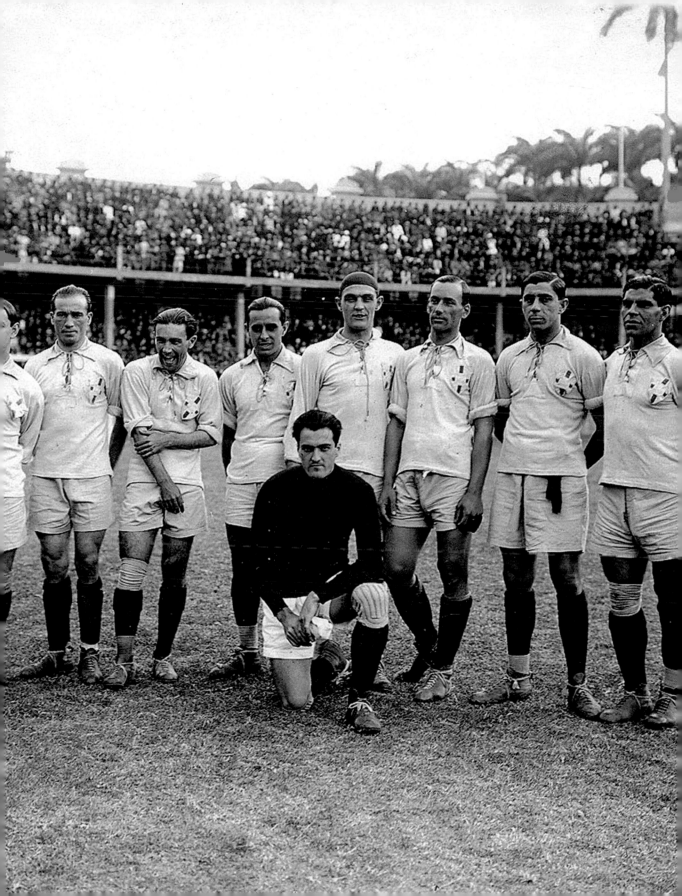

ABOVE: Charles Miller was sent back to England as a boy to attend boarding school at Banister Court in Southampton. Here he not only studied hard but enjoyed the sporting environment, and football in particular. The young Miller admired the style and gentlemanly ethos of the leading amateur club Corinthians. Later he helped organize one of their first tours to Brazil, which inspired the creation of the Sao Paulo club of the same name.

OPPOSITE: Oscar Cox was one of the leading early football enthusiasts in Rio de Janeiro. He "discovered" football while a student in Lausanne, Switzerland, and returned to Brazil as a dedicated missionary for the game. Subsequently he founded Fluminense and set in train the movement which led to the city's established rowing clubs creating sections devoted to this new sport from the old world.

That same year the enterprising Cox organized two games in Sao Paulo against Miller's new football enthusiasts. One of the country's great football rivalries was up and running – and Brazilian futebol with it.

Sporting pastimes, until the closing days of the 1800s, had been largely for the upper classes. In the early years of the nineteenth century horse racing was a favourite entertainment within the royal court. Racing was organized along Botafogo beach for the enjoyment of the nobility, doubtless encouraged by an English influence: Britain and Portugal were, after all, the oldest of allies.

The Club de Corridas, an early horse race society, was founded in 1849. A track was laid out close to the site now occupied by Maracana. A Jockey Club, after the British model, was founded in 1854, collapsed and revived in 1868. Similar bodies were launched in Belo Horizonte, Curitiba, Porto Alegre and Sao Paulo.

Change began in the late nineteenth century with the declaration of a republic after the overthrow of Emperor Pedro II in 1889. A new breed of businessmen and industrialist emerged, while a rising militarism and the European-influenced Jesuit colleges placed an increasing emphasis on health and physical fitness.

While this was not the muscular Christianity of the Victorians in England, in their public schools and universities, it might at least be considered a Brazilian translation.

From here it would be but a short step to the concept of sport for the masses. Initially that meant cycling and, particularly, rowing at the Rio beaches. More than two dozen rowing clubs were founded. These included the Clube de Regatas Fluminense in 1892 and the Clube de Regatas do Flamengo in 1895.

This awakening to sport was timed perfectly for young Charles William Miller.

Miller's father had been one of three émigré sons of Scotland. He worked on the railway between Sao Paulo and the port of Santos and married, as was proper among the expat community, one of their own.

John Miller and wife Carlotta had four children of whom two died in childhood.

Sons John and Charles survived and were duly dispatched to Banister Court School in Southampton in 1884. John was 12, Charles nine.

Their father died two years later and brother John from dysentery in 1892. Charles stayed on in Southampton and took up football with St Mary's (now Southampton) Football Club. In 1894 he was informed that a position awaited him in the Sao Paulo Railway Company, and so he sailed for home ... with two footballs and a Hampshire FA copy of the laws of the game in his luggage.

The rest is history. Miller was a co-founder of the Sao Paulo league, which claims to be the oldest in Brazil, and led Sao Paulo Athletic Club to victory in the first three championships in 1902, 1903 and 1904.

Back up in Rio, in 1902, Cox had impelled the creation of a Fluminense football team and been elected its first president. Four years later he was a leading light in organizing the first Rio de Janeiro championship (Campeonato Carioca). Six English-dominated clubs took part and Fluminense were the historic first winners.

Spectators turned up. Some were expats, supporting their friends and relations. More and more of them, as time went on, were Brazilians of all classes and financial status. Initially they wandered along out of curiosity at these strange manifestations. Quickly curiosity evolved into enjoyment and then into passion. Rowing and horse racing had been exclusive to the middle and upper classes, but futebol was for everyone.

Flu's captain was now Alberto Borgerth who rowed, conversely, for Flamengo. Five years later a dispute within Flu over team selection prompted Borgerth and nine other players to walk out. They had no wish to throw in their lot with rivals Botafogo or English-dominated Paysandu in the south of Rio, while America and Sao Cristovao were too far to the north.

❝I am told 2,000 footballs have been sold here within the last 12 months. Nearly every village has a club. ❞ *Charles Miller, writing about the growth of the game in Brazil, in 1904*

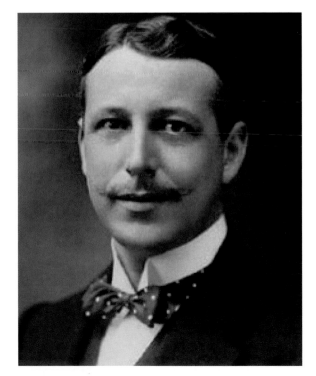

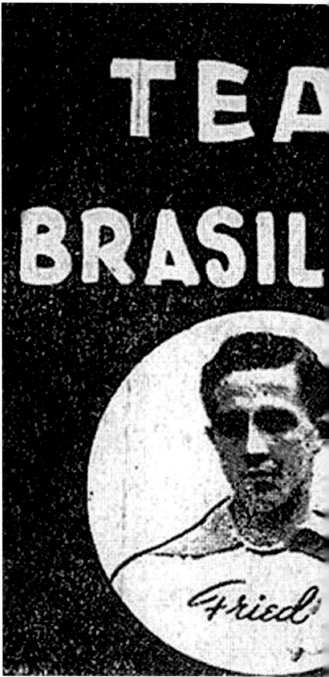

ABOVE: The first English club to play in Brazil on tour were Exeter City. In the summer of 1914 they undertook an 18-day voyage to South America on the *SS Andes* for a series of matches in Argentina and then Brazil. They won every match except for the last one, played on July 21 in the Estadio Laranjeiras in Rio against a combined Rio–Sao Paulo XI. This time the Brazilians, including Arthur Friedenreich, won 2–0.

RIGHT: The first poster boy of Brazilian football. Arthur Friedenreich is considered the country's first footballing superstar, though claims that he scored more than a thousand goals in his career are now regarded as exaggerated. Nicknamed "El Tigre" (The Tiger), he played for a dozen clubs in his career and, as a mulato, was the first non-white Brazilian footballer to achieve widespread fame and popularity.

"In that case," said Borgerth, "we must become Flamengo."

Loyally they played one last, scheduled match for Fluminense before resigning and persuading Flamengo to launch a football team. A general meeting on November 8, 1911, approved the creation of a Departamento de Desportos Terrestres (land sports).

The following May the Liga Metropolitana de Sports Athleticos kicked off a new season with eight clubs: America, Fluminense, Rio Cricket and Athletic Association, Paysandu Cricket Club, Sport Club Mangueira, Sao Cristovao Athletic Club, Bangu Athletic Club and . . . Club de Regatas Flamengo.

In fact Bangu lay claim to an alternative importer of the first footballs in Thomas Donohoe, a Scottish employee of Platt Brothers, then the most expansive textile machinery company in the world.

Whatever or whoever . . . within a decade club competition was not only established but reflecting the complexities of a developing society across the nation. Flu–Fla, however, remains the most traditional of club rivalries for reasons which go all the way back to the schism of 1911.

The power of the city and then state leagues remained predominant. It took the transforming arrival of floodlights and the jet engine – factors which revolutionized European football in the late 1950s – before a national championship was created in the late 1970s.

By then a passion for football had spread throughout South America. A European-based world football federation, FIFA, had been created in Paris in 1904. That was a world away in terms of time and communications, so the South Americans had organized themselves.

A Brazilian sports confederation was created on June 8, 1914, and a South American confederation (CONMEBOL) two years later after Argentina had hosted an inaugural Campeonato Sudamericano de Futbol, now known as the Copa America.

Representative teams were thrown together regularly in Rio and/or Sao Paulo (still known as "scratch" teams) to play visiting English teams including Corinthians and Exeter City. But the first formal national team was the one sent to Argentina for the South American championship of 1914: Marcos, Pindaro, Neri, Lagraca, R. Salles, Pernambuco, Gomes, Bartolomeo, Milton, Friedenreich and Arnaldo.

Brazil finished third but, along the way, beat Argentina 1–0 in the nations' initial official meeting. The goal was scored by Arthur Friedenreich, first superstar of Brazilian football.

Arthur was the son of Oscar Friedenreich, a German immigrant businessman, and Matilde, a black laundrywoman. Born on July 18, 1892, he soon showed an aptitude for sport. At 20 he was top scorer in the Sao Paulo championship and earned a place in a Paulista Select against an Argentina XI. Losing 3–0 at half-time, Sao Paulo hit back to win 4–3 with "Fried" scoring twice.

That was just the start. He scored goals wherever he went and inspired Brazil's first Copa America triumph in Rio in 1918. That was when a Uruguayan journalist awarded him the lifelong nickname of "El Tigre" (The Tiger).

In 1925 Friedenreich was a sensation when a Sao Paulo Select toured France and Switzerland. One French journalist described the Brazilians as "superior, even, to the Uruguayans who won the Olympic Games football tournament here in Paris last year".

Friedenreich remained a hero of the club game, retiring after a farewell friendly against Argentina's River Plate in 1935, at 43. Legend ascribed to him a career total of 1,329 goals. Later research came up with a more realistic 554 goals in 561 games. No matter. His place in Brazil's football pantheon had long been secure.

More's the pity that he did not play for Brazil at the inaugural 1930 World Cup finals in Uruguay.

> **"They [Exeter] were the first English team we had seen. We were told they were giants. But they were just men, like us."**
>
> *Arthur Friedenriech after a Rio–Sao Paulo XI beat visiting Exeter City 2–0*

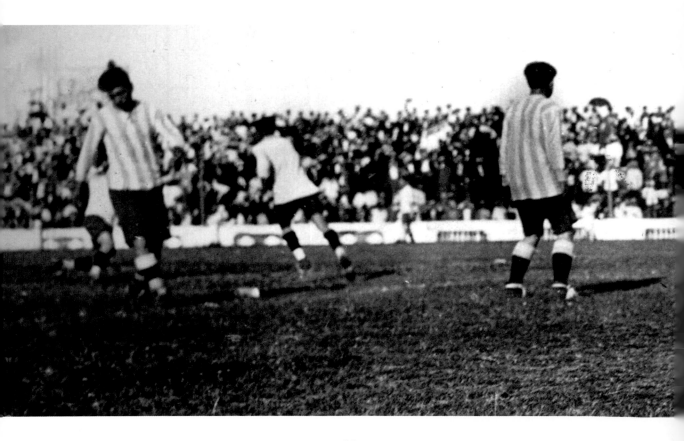

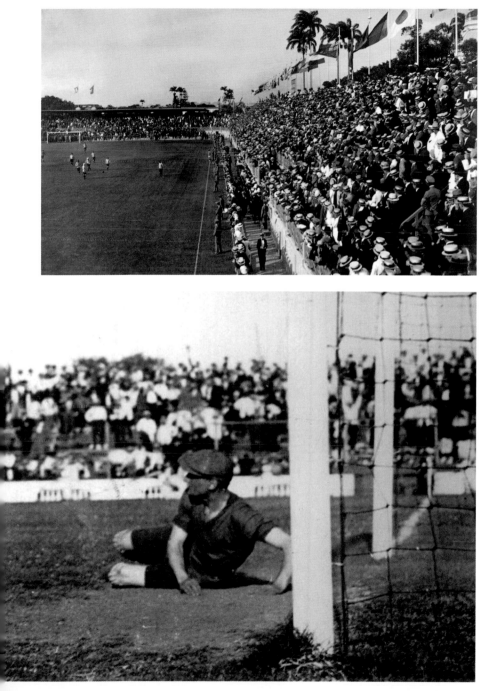

LEFT: By the 1920s crowds of well over 20,000 were common at club matches in Rio de Janeiro and Sao Paulo. This was an era which saw professionalism rapidly gaining ground and players becoming popular heroes. Between the 1950s and early 1970s vast new stadia were built the length and breadth of the country, and crowds of well over 100,000 were regularly reported for club games from Sao Paulo to Belo Horizonte to Rio.

BELOW LEFT: Argentina's goalkeeper Americo Tesorieri lies beaten by a Brazilian goal in the final match of the 1925 South American championship. Chile and Uruguay had withdrawn before the tournament, so only hosts Argentina, Brazil and Paraguay competed. They all played each other twice, after which Brazil needed to beat Argentina to secure the right to a play-off for the title. Arthur Friedenreich opened the scoring but the game, played on Christmas Day, ended 2–2 and Argentina were crowned champions.

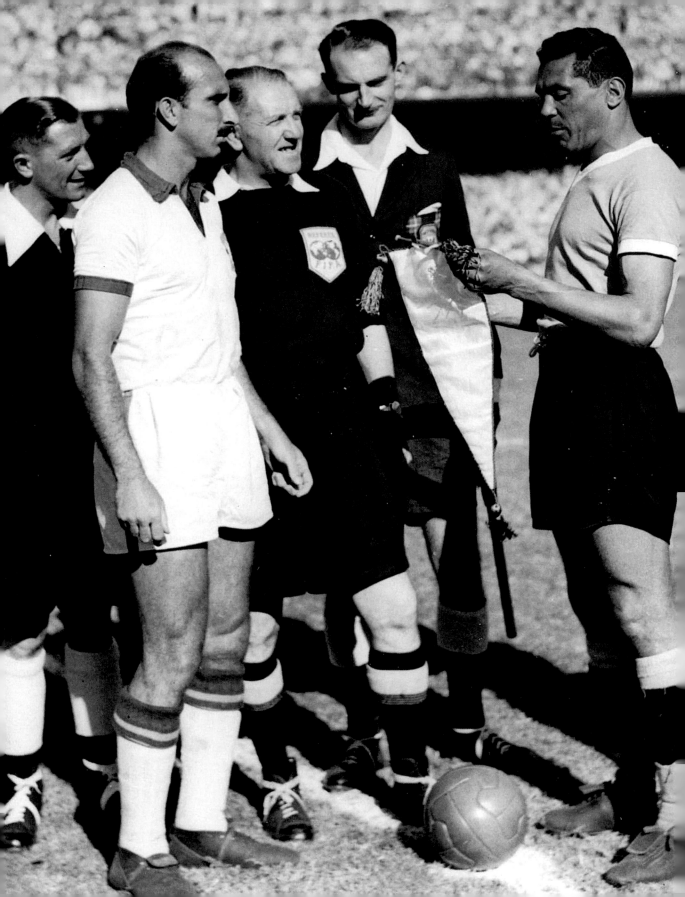

Chapter 2
THE FATEFUL FINAL

Brazil's first World Cup-winning footballer was not Pele or Garrincha or Didi or any of their contemporaries. He was Anfiloquio Guarisi and he played for winners and hosts Italy at the 1934 finals. Guarisi was known in Brazil as Filo. He had been playing for Corinthians of Sao Paulo when, in 1931, he joined a growing exodus of South American talent.

Guarisi's destination was Lazio of Rome, where he played alongside the three Fantoni brothers, also Brazilian.

Various factors had exerted pressure to emigrate on Brazil's best. The country's economy had suffered from a collapse in the world coffee price exacerbated by the worldwide fall-out from the Wall Street crash; street unrest was growing as the Republica Velha (Old Republic) tottered towards its end; and domestic football was riven by a "class war" dispute between amateurs and professionals. The twin, warring power centres of the game were Rio de Janeiro and Sao Paulo. In simple terms, Rio represented the amateur elite; Sao Paulo represented working-class professionalism.

A national sports association, the Confederacao Brasileira do Desportes (CBD), had been created in 1916. Its raison d'être was to resolve the Carioca–Paulista wrangling. Success was slow and limited. Indeed the wrangling continues to this day, though nowadays over finance, sponsorship and television rights rather than playing issues.

In 1930 Brazil had become the second South American nation, after Argentina, to join the fledgeling world federation, FIFA. This also brought it the task of selecting a squad for the inaugural World Cup in Uruguay in 1930.

LEFT: English referee George Reader (centre, with ball) brings together captains Augusto da Costa of Brazil (left) and Obdulio Varela of Uruguay before the final match of the 1950 World Cup. Augusto knew he and his team-mates had an advantage since Brazil needed only a draw to secure the Jules Rimet Trophy for the first time; Uruguay had to win. Hence all of Brazil expected nothing less than glory.

A mix of Rio and Sao Paulo players was named, but the APEA objected that all the selectors were Rio-based and barred their players from travelling to Uruguay. Those players included Brazil's finest player, Artur Friedenreich. Only one player disobeyed orders: Araken from Santos. He played in Brazil's opening 2–1 defeat by Yugoslavia and was dropped for the subsequent 4–0 win over Bolivia, their second and last game. Not until 1966 would Brazil fail again to progress beyond a group stage.

"Filo" Guarisi did not make the squad. But he played four times altogether for Brazil before sailing for Italy. He qualified for the Azzurri because of his parental origins – as he also qualified for national service.

Italy manager Vittorio Pozzo, questioned about dual nationality players from not only Brazil but also Uruguay and Argentina, always answered: "If they can die for Italy then they can play football for Italy."

Guarisi, his first name "Italianized" as Anfilogino, made only one appearance in the 1934 finals. That was in their opening 7–1 thrashing of the United States, but he was among the players celebrating deliriously after Italy's 2–1 win over Czechoslovakia in the Final. By then his old Brazilian team-mates were on the high seas heading for home.

The CBD, with the domestic game still squabbling, had selected a squad of amateur players. After a public outcry they selected a new squad including a sprinkling of "open" professionals and agreed to pay all the players, including the amateurs. The price of compromise was speedy failure. The tournament was played on a knockout basis and Brazil played only one game, losing 3–1 to Spain.

> **"No one realised, in Uruguay in 1930 at the inaugural World Cup, that we were making history."**
>
> *Lucien Laurent, the France forward who scored the first World Cup finals goal*

But lessons had been learned. Brazil's delegation in Italy had been led by Lourival Fontes, who was also Propaganda and Culture Minister under President Getulio Vargas. Lourival and Vargas understood the enormous potential of radio. The first transmissions were in 1920. Yet it was only a decade before football match commentaries were being broadcast and a powerful link was forged between the media and the game which exists to this day.

In no country – not even in the rest of football-mad South America – is radio as much an embedded factor in football. One famous fan is even known as Ze do Radio for the enormous mock radio he carries around the grounds on his shoulders.

Radio coverage enhanced the magnetism and popularity of the game across all classes – from elite to illiterate – and its potential for kids from the wrong side of the tracks.

Vargas had been installed as President by the army after losing the 1929 election. He stepped up industrialization with a political philosophy influenced

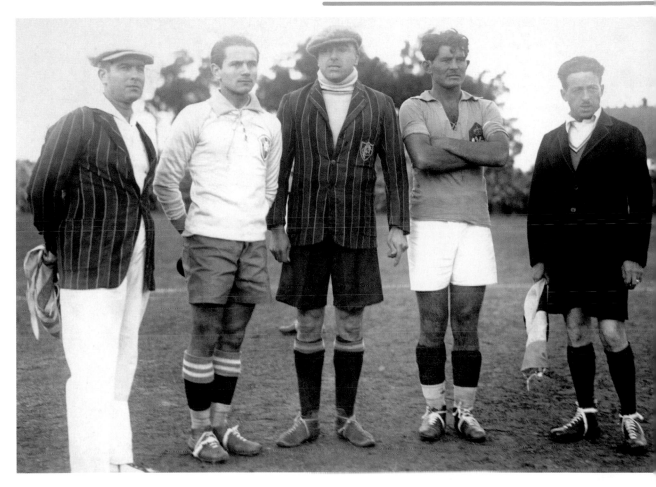

ABOVE: The formalities ahead of Brazil's World Cup debut in Montevideo on July 14, 1930. Uruguayan referee Anibal Tejada is flanked by captains Milutin Ivkovic of Yugoslavia (left) and Preguinho (Joao Coelho Netto) of Brazil (right). Either side of the trio are linesmen Ricardo Vallarino (Uruguay) and Thomas Balvay (France). It was the most inauspicious start: Brazil lost 2–1 against the prospective semi-finalists.

RIGHT: All aboard as Brazil's players and officials head for Genoa and their opening match in the 1934 World Cup in Italy. The first European finals were organized on a knockout basis. Hence Brazil's subsequent 3–1 defeat by Spain meant they had sailed the Atlantic and then taken this bus trip for just one single game.

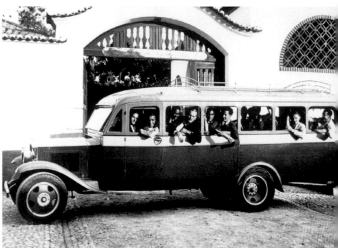

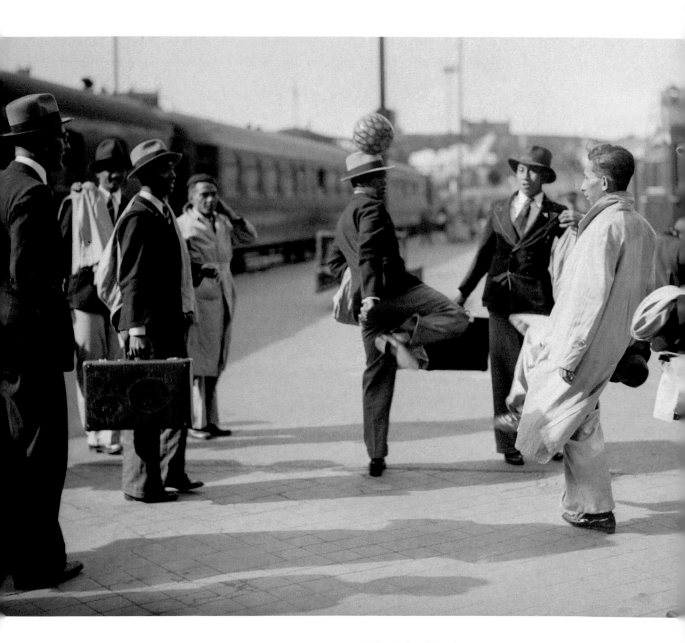

ABOVE: Brazilian players entertain themselves while awaiting the train taking them down from Paris to Marseilles for their 1938 World Cup semi-final against Italy, the holders. All the teams playing at the finals in France travelled by train or bus. Note the formal dress style: suits and ties, hats and raincoats. No tracksuits for travel back then.

by the fascist example of Italian dictator Benito Mussolini. One by-product was a resolution of football's class war with the triumph of professionalism.

Hence the players Brazil sent to the 1938 World Cup in France were the best available. The new superstar successor to Friedenreich was centre-forward Leonidas da Silva, credited with inventing the overhead bicycle kick and nicknamed the "Diamante Negro" (Black Diamond).

Leonidas had scored Brazil's lone goal against Spain in the 1934 finals and struck a hat-trick in their 1938 opener against Poland. Brazil won 6–5 after extra time. The classic entered World Cup legend as the only tie in finals history in which one player on each side scored a hat-trick. Leonidas was out-shot by Ernst Willimowski, who scored four for the beaten Poles.

Czechoslovakia were then beaten in the quarter-finals but only after a replay. Leonidas struck in the initial 1–1 draw and then again in the 2–1 follow-up success in Bordeaux. In confident mood, Brazil took the train to Marseilles and a semi-final showdown against World Cup holders Italy. But two days was not long enough for Leonidas to recover from a bruised back. Manager Ademar Pimenta might have replaced him with Brazil's finest other forward, Tim. But Pimenta and Tim had fallen out even before the squad set sail. Without either potential match-winner Brazil went down 2–1.

> **❝Only the good Lord above can help you when Leonidas decides he is going to shoot for goal.❞**
> *Frantisek Planicka, Czech goalkeeper-captain at the 1934 finals*

Leonidas returned for the third place play-off and scored twice in Brazil's 4–2 victory over Sweden. But it was poor consolation as the delegation headed for home ... leaving Europe headed for war.

Life in Brazil went on comparatively unaffected by the conflict. Initially Vargas's sympathies were with Germany and Italy but that changed after the United States became involved. The pragmatic Vargas agreed a series of favourable trade agreements with the US and, in the closing stages of the war, a Brazilian brigade even joined the Allies in fighting their way up through Italy.

Back home, football played on. New heroes emerged. Not only that, but Brazil was in a strong enough position to bid to host the first post-war World Cup. Initially, cash-strapped FIFA scheduled the finals for 1949. When Brazil decided it might struggle to be ready on time – shades of a World Cup to come! – the finals were put back to 1950.

In 1934 and 1938 the World Cup had been run as a knockout tournament. For 1950 FIFA reverted to the 1930 concept of first-round groups but with the four group winners playing in a mini-league to decide the champions.

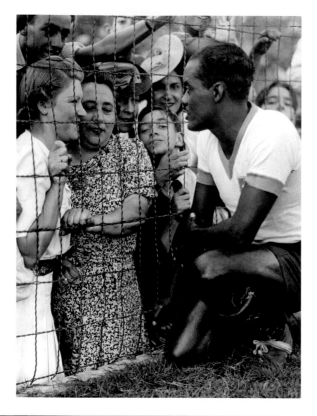

A preliminary competition produced 15 qualifying nations of whom, for a variety of odd reasons, only 12 turned up to join Brazil.

The 12 included England, the original masters of football. They appeared in the finals for the first time after the Football Association's rapprochement with FIFA. England were installed as joint favourites with a Brazilian side which bristled with talent. The inside-forward trio of Zizinho, Ademar and Jair remain legends both as a unit and as individuals.

Brazil provided six venues: Recife in the north-east, Porto Alegre in the south, plus the more central Curitiba, Sao Paulo, Belo Horizonte and Rio de Janeiro. The vast new Maracana in Rio was still a building site when the tournament began. Remarkably it was named in honour of the journalist Mario Filho who had led the way in championing the game, Brazil's role and the finals.

Belo Horizonte provided one of the greatest shocks of this or any other World Cup when the apparent no-hopers of the United States defeated shocked England 1–0. Elmo Cordeiro, a ball boy at the match, told this writer: "We cheered for the Americans. Not because we liked them particularly but because defeat for England made it easier for Brazil to win the World Cup."

ABOVE LEFT: Leonidas da Silva meets some of his new fans after training at the 1938 World Cup in France. Brazil's centre-forward scored seven goals on his second appearance at the finals after scoring only one at the 1934 tournament. Leonidas's matinée idol looks off the pitch and flamboyant acrobatics on it earned admiration from football fans of both sexes.

LEFT: Brazilian goalkeeper Walter Goulart punches both the ball and an Italian forward in the 1938 World Cup semi-final in Marseilles. Brazil badly missed Leonidas because of a back injury, as well as Tim, who had fallen out with manager Ademar Pimenta. Italy won 2–1 and went on to secure the World Cup for a second time. Reaction back in Brazil was muted. Little had been expected of a team weakened by political divisions in the domestic game.

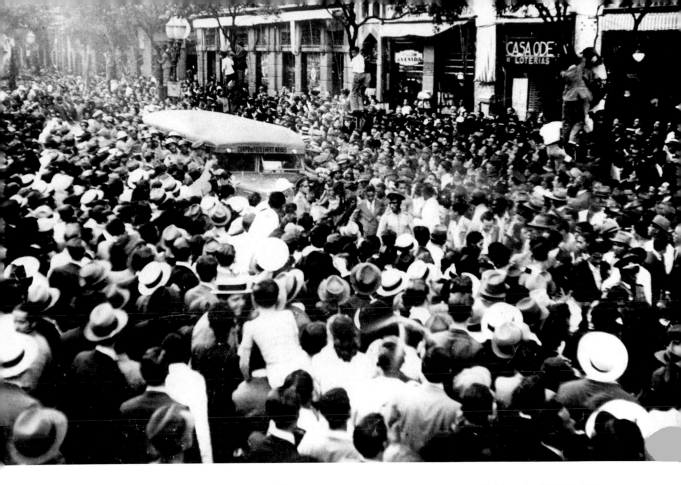

So he – and all the nation – thought. Brazil beat Mexico 4–0 and Yugoslavia 2–0 in Group One and struggled only against Switzerland. The Swiss grouped around their defensive tactic known as the "Verrou" (Swiss Bolt) and snatched a 2–2 draw. No matter. Brazil still topped the group and sailed into the final round. Ademir de Menezes scored four in a 7–1 rout of Sweden and was on target again, along with inside-forward partners Jair and Zizinho, in the subsequent 6–1 trouncing of Spain.

The final match was against a Uruguayan side who had dropped a point against Spain. Hence Brazil needed only a draw to top the table and lift the World Cup; Uruguay had to win.

No one had any doubt about the outcome. One newspaper printed a poster, three days before the game, with a picture of the Brazilian team proclaimed as "Champions of the World". Even some of the delegation from the Uruguayan federation were so convinced of the outcome they left for home the day before the game.

> **Leonidas was the first of our Brazilian footballers to have a press agent to polish up his image.** *Andre Ribeiro, Leonidas' friend and biographer*

The crowd which packed Maracana ready to celebrate has been estimated at around 200,000, though it may have been more: crowds flooded over walls and gates to share what was expected to be the greatest event in Brazilian sporting history. In all of Brazilian history, to listen to some of the veterans of the occasion.

They had no reason to doubt. Brazil went close to scoring three times in the first five minutes. At half-time the game was still goalless but victory only a matter of time. Even better, two minutes after the restart left-winger Friaca shot Brazil ahead.

Maracana was happily cheering Brazil on to glory when, in the 66th minute, Uruguay equalized through their great inside-forward Juan Schiaffino. No worries. A draw was still sufficient. Then: disaster. Uruguay broke away. Julio Perez released right-winger Alcides Ghiggia. He outpaced Bigode, cut into the penalty box and shaped to cross. Goalkeeper Moacir Barbosa threw his weight on to his right foot and stepped forward in anticipation ... and Ghiggia drove the ball between keeper and post. Silence.

Brazil, shattered, could barely pass the ball between each other let alone mount a serious, retaliatory attack. The final whistle from English referee George Reader signalled victory for Uruguay and a string of reported heart-attack deaths both inside the stadium and across the country.

Poor Barbosa bore the brunt of the nation's pain for the rest of his life. Years later, on seeking to visit the "Selecao" (Selection) before a big game to wish them luck, he was turned away in case his visit should prove a bad omen. From similar superstition, it was more than a decade before Brazil dared select a black goalkeeper again.

Before his death in 2000, Barbosa once told a friend: "The worst was in the street one day when I heard a mother tell her little girl: 'Look, that's the man who made all Brazil cry.'"

"All" Brazil, that July 16 in 1950, had included one nine-year-old boy in a town deep in Minas Gerais state. Years later he remembered "crying and crying and crying". His name was Edson Arantes do Nascimento. For reasons no one quite knows, his friends called him Pele.

❝I'm told the commentator just said: 'Uruguayan goal.' He was so shocked he didn't even name me. ❞

Alcides Ghiggia, scorer of the winning goal in the 1950 final match

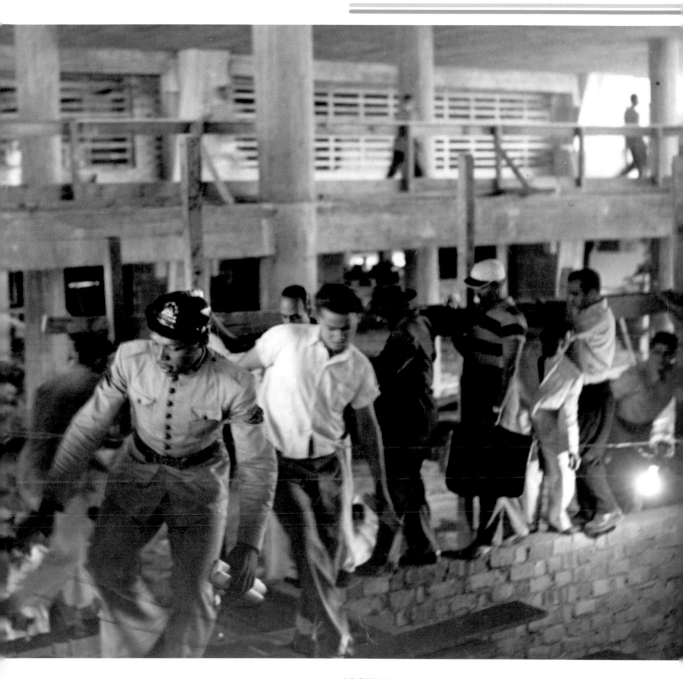

ABOVE: Work was still being undertaken inside the giant new Maracana stadium when Brazil welcomed the international game for the 1950 World Cup finals. Brazil even took the lead in a game against Yugoslavia while one of the visiting players was being treated for gashing his head on one of the unprotected steel girders inside the ground.

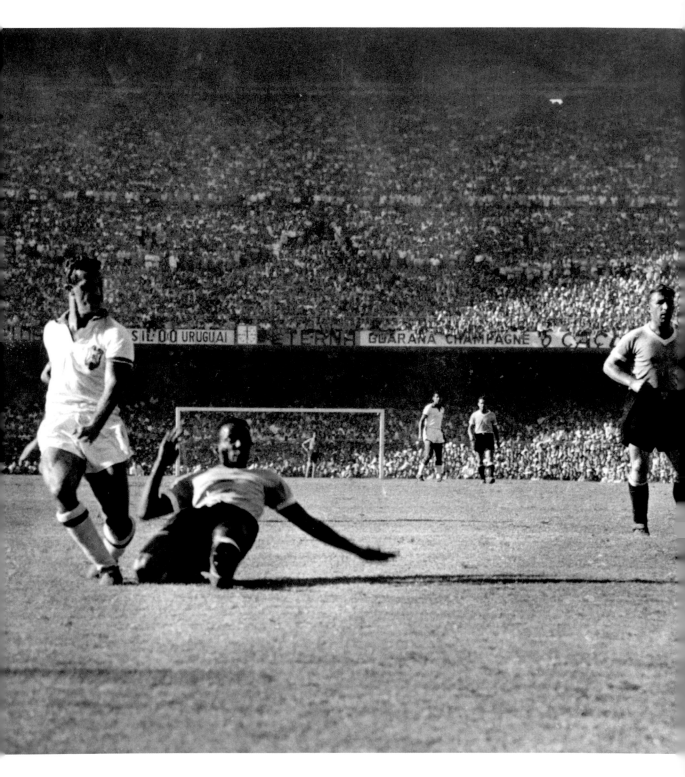

LEFT: Brazil's massed wall of support within the Maracana – and many thousands outside – believed it was only a formality until their first goal was scored. Their expectant cheers were still-born as Ademir da Guia fluffed this early opening. The tournament's nine-goal top scorer sliced his shot wide under a challenge from Rodriguez Andrade.

BELOW: Down and out. Brazil's goalkeeper Moacir Barbosa is left helpless by the shot from Alcides Ghiggia which fired Uruguay, decisively, 2–1 ahead in the 1950 World Cup Final. Barbosa had left a fatal gap on his left-hand post after moving forward off his line, expecting the Uruguayan right-winger to cross the ball rather than shoot. Brazil were stunned by their loss.

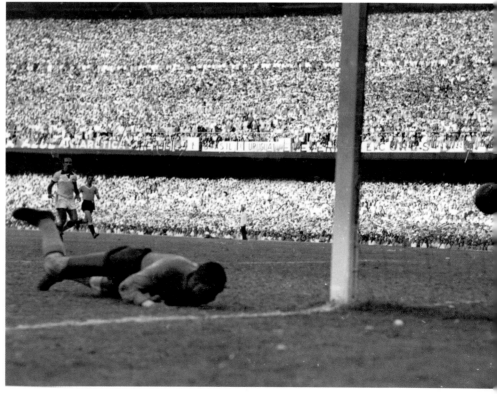

Chapter 3
PELE AND THE GOLDEN ERA

A punch-up, on and off the pitch, heralded the opening of the greatest era in Brazilian football history. The date was June 27, 1954, and the occasion a 4–2 defeat by the Hungarians in the quarter-finals of the 1954 World Cup in Switzerland. Such a dispatch was a huge disappointment for a Brazilian side who had left home cautiously confident.

They had beaten Uruguay to win the 1952 Pan-American Games football title, reached the quarter-finals of the Olympic Games that same year in Helsinki, finished runners-up in the 1953 Copa America and won all their four matches in the World Cup qualifiers.

This was the first time Brazil had played the preliminaries. They had a new manager in Zeze Moreira and a new strip. The all-white in which they had suffered the Maracanazo (the disaster in the Maracana) had been replaced, at the Pan-Am Games, by yellow shirts and blue shorts. The new nickname of "Selecao Canarinho" (Little Canary Selection) stuck.

New heroes had emerged. Notably they included the unrelated full-backs Djalma Santos and Nilton Santos, lithe playmaker Didi and exciting right-winger Julinho. Zizinho was left at home, even though he was still starring domestically for Bangu; he had fallen out with the CBD management during the Copa America.

RIGHT: Respectful rivals Pele and Bobby Moore exchange shirts and compliments after Brazil's 1–0 win over holders England in the group stage of the 1970 World Cup finals in Guadalajara, Mexico. This was England's first defeat in the finals tournament since their elimination in the 1962 finals in Chile by ... Brazil.

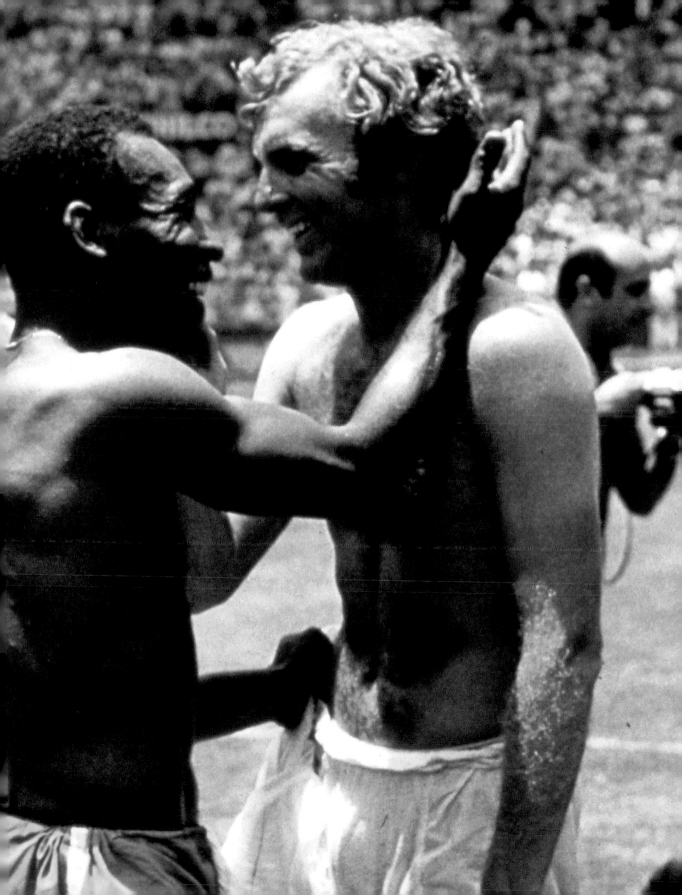

Brazil arrived in Switzerland delighted that the draw offered them a start against weak fellow Latin Americans from Mexico. They won 5–0. The subsequent 1–1 draw against Yugoslavia qualified both nations for the quarter-finals, where Brazil would face Hungary.

Hungary were unbeaten since May 1950 and strode into the finals as odds-on favourites. Thrashings of 6–3 and 7–1 handed out to England at Wembley and Budapest in the previous 12 months enhanced the status gained by their Olympic gold medal-winning success. Against Brazil, they would be without their injured captain and top scorer, Ferenc Puskas. But the Brazilians did not know it until they walked out into the old, wooden Wankdorf Stadium in Bern.

Not that it made any difference. The Brazilian players had already lost their nerve. Moreira had told them to "defend the honour of the national flag". They did so with punches and kicks and were beaten 4-2. English referee Arthur Ellis sent off three players (Hungary's Jozsef Bozsik and Brazil's Nilton Santos and Humberto) in what became known as the Battle of Bern. The fighting raged on in the dressing-rooms after the game.

The footballers headed home in disgrace to a country about to be convulsed by the suicide of President Getulio Vargas.

Brazil, like so many other countries on so many other occasions down the years, needed their sportsmen to provide a distraction from the difficulties of daily life. They did not disappoint. The work was already under way. In 1952 Botafogo took on a kid with legs twisted by childhood illness, named Garrincha; and on September 7, 1956, the port club of Santos saw the debut and first competitive goal of a 15-year-old Pele.

BELOW: Chaos and confusion erupted in the players' tunnel after Brazil's defeat by Hungary in their 1954 World Cup quarter-final. This was the notorious "Battle of Bern" in which three players were sent off and afterwards footballers and officials fought in the tunnel and the dressing-rooms. The root of the violence had been Brazil's nerves heading into a game against the "Magical Magyars".

OPPOSITE: A boy's dream comes true – and Pele was still little more than a boy, having won the World Cup and thus the Jules Rimet Trophy at just 17 in Sweden in 1958. Edson Arantes do Nascimento was the new young hero of international football despite having made his debut in senior football only two years earlier with Santos.

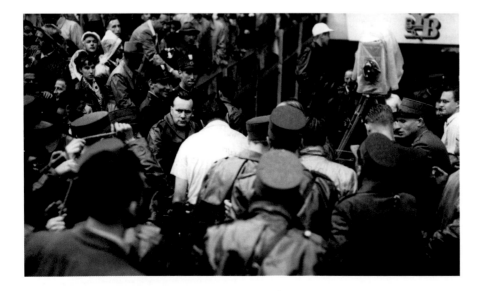

The son of an old player Dondinho (Joao Ramos do Nascimento) whose career had been severed by injury, Pele had been spotted by Waldemar de Brito, who had played for Brazil in the 1934 World Cup.

Garrincha and Pele were the new heroes of the Carioca and Paulista leagues. They played together for Brazil for the first time in the two-leg Copa Roca challenge against Argentina in 1957. Garrincha was 23, Pele still only 15. The following spring both were included by coach Vicente Feola in Brazil's squad for the 1958 World Cup finals.

Feola had been summoned to replace sacked Oswaldo Brandao. That was Brandao's "reward" for managing Brazil successfully through the World Cup qualifiers. Peru alone provided the opposition. The teams drew 1–1 in Lima and the return was decided by a trademark "falling leaf" free-kick from Didi.

Much had changed in four years. Transport millionaire Jean-Marie Faustin Goedefroid "Joao" de Havelange had taken over the presidency of the CBD. A former Olympic swimmer and water polo player, Havelange knew all about winning. Nothing would be left to chance this time. He brought in broadcasting executive Paulo Machado de Carvalho as his deputy, and between them they appointed a new medical chief, Hilton Gosling, who was on the same wavelength. Gosling pulled together a full medical staff including a dentist, heart specialist, chiropodist and psychologist.

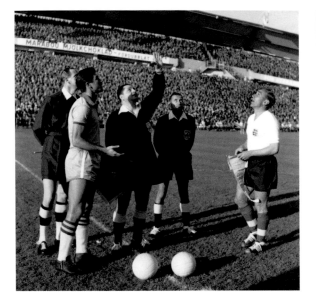

ABOVE: Hungarian referee Istvan Zsolt and captains Hilderaldo Bellini (left) of Brazil and Billy Wright of England watch the spin of the coin before their 1958 World Cup tie. England were the only team not to lose or even concede a goal against Brazil. They had worked out Brazil's tactics and plotted successfully to stifle playmaker Didi.

RIGHT: Nilton Santos in spectacular defensive action for Brazil in the 2–0 win over the Soviet Union, also in Gothenburg, in the 1958 finals. Santos was one of the most experienced and respected members of the squad and played a key role in persuading coach Vicente Feola to put his faith in Garrincha and Pele.

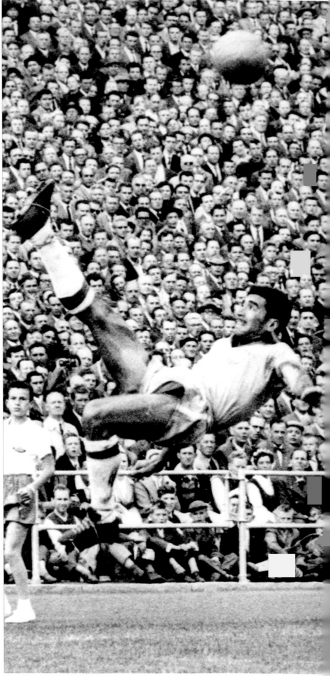

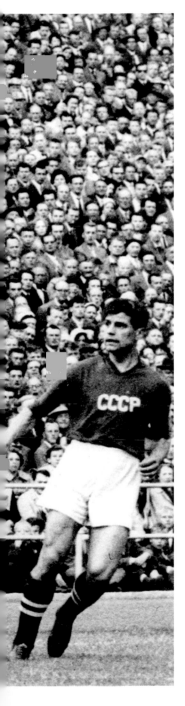

The latter, Joao Carvalhaes, was the most controversial addition to the support squad. He reported to Feola that neither Garrincha nor Pele had the mental capacity to cope with the stresses of a World Cup. Garrincha was outstanding in a pre-finals friendly against Fiorentina in Italy, but Pele was carrying a knee injury. Feola, cautiously, left both out of the opening two games at the finals – a 3–0 win over Austria and goalless draw against England.

Brazil were using a tactical shape which was now common in South America but which was an eye-opener to the Europeans. Brazilian coaches had reorganized the old WM – with an attacking centre-half – into what was labelled as 4–2–4. The right-back remained in place but the centre-half dropped back alongside him, partnered by the old left-back. The former left-half retreated to become a left-back.

Hence, until the advent of squad numbers, Brazilian teams traditionally lined up 2-5-3-6 (or 2-3-4-6) across the back. In what was now described by the revolutionary term of "midfield" the old right-half (No. 4) or attacking centre-half (No. 5) linked up with the deep-lying inside-right (No. 8). The wingers stayed wide and No. 10 pushed up in closer support of the traditional centre forward.

> ## ❝No matter how fast the winger, Nilton Santos was always alongside him, waiting for the right moment to tackle.❞ *Billy Wright, England captain, 1958 World Cup*

England had watched Brazil in their opening game, sussed out the system and sat Wolves' wing-half Bill Slater tight on Didi in midfield. Brazil's attack misfired. The tactics were fine; the personnel were not.

Nilton Santos, most senior of the players, pulled Feola to one side after training and suggested the team needed more explosive unpredictability. Against the much-feared Olympic champions from the Soviet Union, World Cup newcomers, Santos urged the inclusion of Garrincha. It was win or bust. So Feola went one step better: he included not only Garrincha but Pele as well.

Garrincha ripped the Soviets apart: centre-forward Vava scored both goals in a 2–0 win which secured top spot in the group and a quarter-final against Wales.

The Welsh were playing the finals for the only time in their history. They took a lead from England and defended with commitment and organization. Only once did Brazil find an opening but that was enough: Garrincha passed to Didi and Pele scored his first, and probably most important, World Cup goal.

Momentum and confidence were building and attracting the essential extra quality of good fortune. In the semi-finals France centre-back Robert Jonquet was injured and, in the days before substitutes, Brazil romped home 5–2. Vava and Didi scored in the first half, Pele three more in the second.

RIGHT: Is that about me? Pele and his Brazilian team-mates enjoy the newspaper reports praising their skill and technical brilliance at the 1958 finals in Sweden. Journalists – and managers and coaches too – were equally fascinated by the 4–2–4 tactical system which European fans were seeing and learning about for the first time.

BELOW RIGHT:

Behind the scenes, coach Vicente Feola (right) discusses how to improve Brazil's performance with midfielders Dino Sani (left) and Didi. Feola replaced the thoughtful Dino Sani after the first two games with the more energetic Zito. Didi remained in place as the World Cup-winning playmaker supreme.

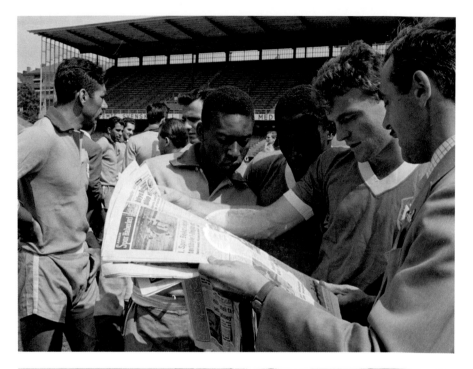

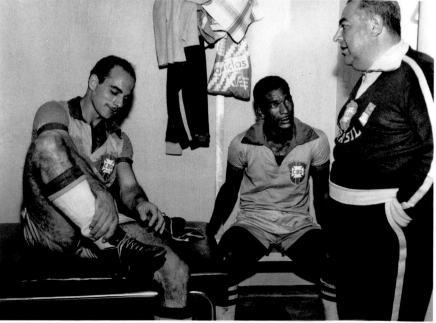

The final was a repeat scoreline: 5–2 against the hosts, Sweden, who had even taken an early lead. Garrincha pulled them apart on the right and Vava and Pele – with two goals apiece – took killing advantage. Outside-left Mario Zagallo scored the other goal. Pele's first, an audacious example of his technical brilliance as he chipped the ball over a defender's head before volleying home, declared his genius before all the watching world.

Finally all Brazil's passion for football and massive potential had fused into both performance and result. Art and ambition would produce a record five World Cup triumphs, but the first was the most important. Captain Hilderaldo Bellini received the trophy from King Gustaf then turned to the stadium and raised it high, with both hands, above his head.

The moment and the image is captured in a statue at the entrance to Maracana: it encapsulates the crowning moment when Brazilian football could proclaim itself head and shoulders above everyone else. This also heralded an era in which Brazil produced perhaps its greatest flourish of talent.

Santos and Botafogo rivalled Spain's "old guard" of Real Madrid and Barcelona as the greatest club teams in the world. Botafogo boasted Didi, Garrincha and and workhorse left-winger Mario Zagallo; while emerging from their shadows were future World Cup-winning heroes such as the precocious Amarildo and explosive Jairzinho. But Santos had Pele, the pearl of great price whom everyone wanted to see.

Not that he found it easy to cope with the attention of gawking admirers. He even stopped attending church. "Being stared at by hundreds of eyes is difficult enough," he said, "but in church it seems even worse than anywhere else."

Santos won both the South American Copa Libertadores and World Club Cup in consecutive years, 1962 and 1963, but thereafter concentrated less on competition and more on generating millions of dollars (preferably in hard cash) from circus-act tours of the world.

> **"Pele and Garrincha could both open the way to victory through seas which no one else dreamed of sailing."** *Mario Filho, legendary Brazilian football journalist*

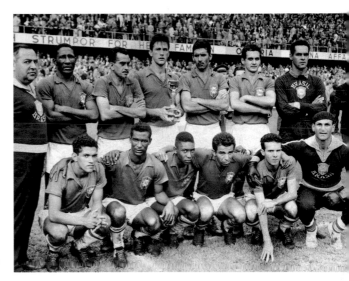

ABOVE: The men who made history; the first Brazilian team to win the World Cup by defeating hosts Sweden in the Final in Stockholm on June 15, 1958. Back (from left): coach Vicente Feola, Djalma Santos, Zito, captain Bellini, Nilton Santos, Orlando and goalkeeper Gilmar. Front: Garrincha, Didi, Pele, Vava and Zagallo.

NEXT PAGE: Mario Zagallo (No. 7) is pulled to his feet by Garrincha (11) and Pele after goalmouth action in the 1958 Final between Brazil and Sweden. Centre-forward Vava (20) puts his hands to his head in frustration at a chance wasted. But Brazil would still end up as the only team ever to score five times in a World Cup Final.

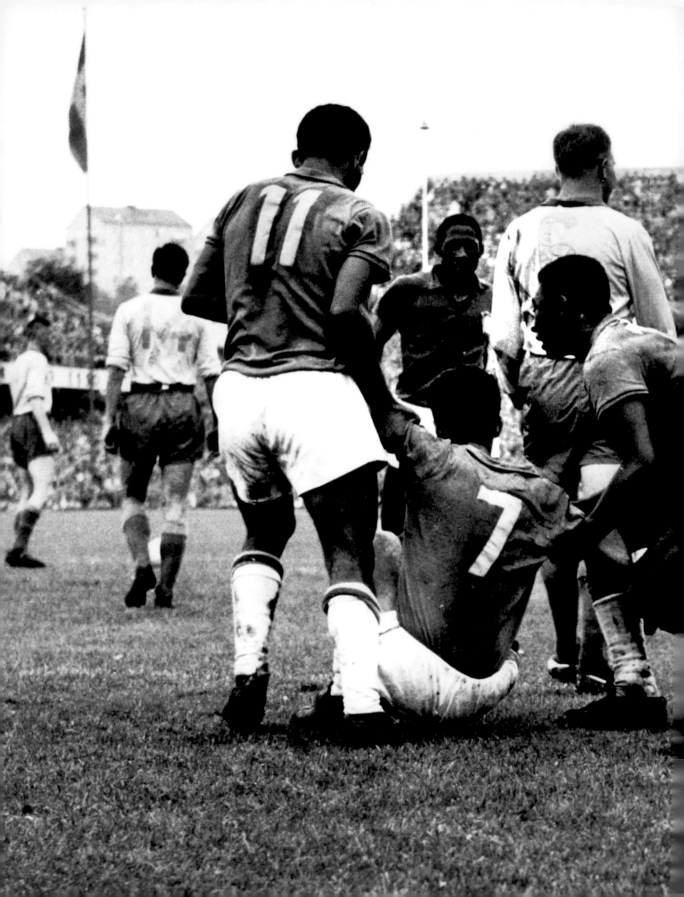

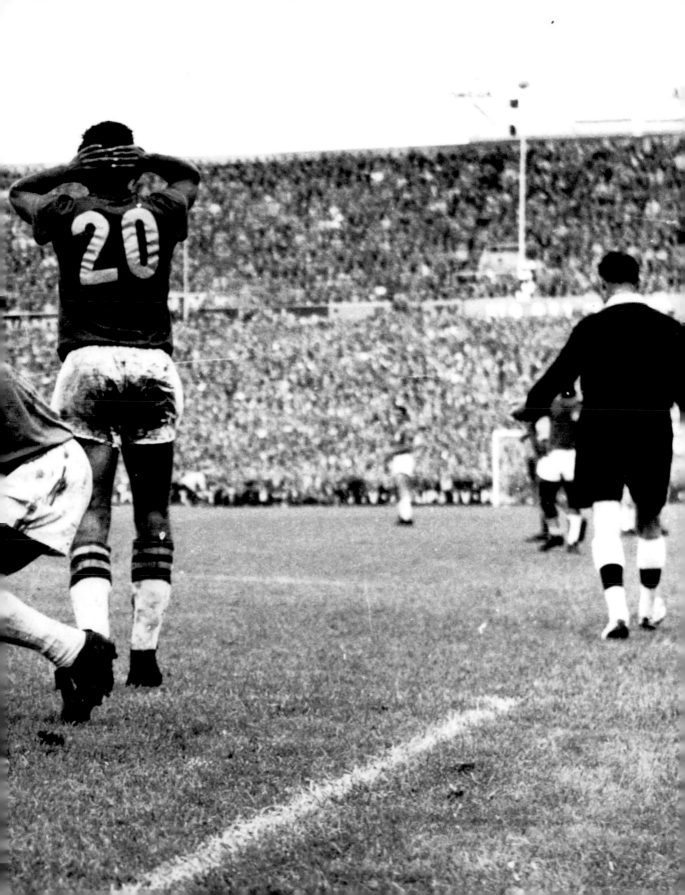

Football's Harlem Globetrotters boasted not only Pele but his "attacking twin" Coutinho, thunderous shooting left-winger Pepe, high-speed right-winger Dorval and a host of fellow World Cup winners in the likes of goalkeeper Gilmar, midfield powerhouse Zito and the statuesque central defender Mauro.

"*We came home understanding how Brazil's preparation, down to the last possible detail, was the way to go.*" *Ray Wilson, England's left-back in the 1962 and 1966 World Cups*

No wonder European clubs sent their scouts and managers scouring the length and breadth of Brazil for talent, even in those far pre-Bosman days when every national league enacted rules and regulations restricting the number of foreign players a team could field – and this was also an era when no exemptions existed for players from other members of what was then the fledgeling Common Market, precursor of the European Union.

Not that South Americans were strangers to Latin Europe. But the Spanish language connection meant clubs had preferred to shop in Argentina and Uruguay, Chile and Colombia, rather than in Brazil. Some Brazilians had made it work, notably in Italy. "Filo" Guarisi and the Fantonis had starred at Lazio in the 1930s; then Julinho, Garrincha's predecessor on the right wing for Brazil, enjoyed dramatic success at Fiorentina in Florence in the mid-1950s.

Fiorentina, in 1955, interrupted the Italian title hegemony enjoyed by the giants of Turin and Milan with a barbed-wire defence and a blow-torch attack in which Julinho fed the creative talents of Chilean Miguel Montuori and Italian centre-forward Giuseppe Virgili, nicknamed "Pecos Bill" for his obsession with cowboy comics.

In Spain, prolific Barcelona looked for goals not only to Hungarian exile Sandor Kocsis but to Brazilian Evaristo de Macedo, who had starred for Flamengo. Then Brazil's 1958 World Cup triumph raised the market bar still higher.

Milan bought two of the 1958 squad. One was cultured midfielder Dino Sani, the other was centre-forward Jose Altafini. Both would be key members of the Milan side crowned first Italian winners of the European Champions Cup in 1963. Curiously Altafini had been known in Brazil as Mazzola because of his resemblance to the Italian football hero killed with the rest of the Torino team in the 1949 Superga air disaster.

Milan also signed a winger, Germano, who came and went within a season; another black winger, Jair da Costa, was twice a European club champion with neighbours Internazionale. But no one in Spain or Italy could prise Pele away from Santos, however hard they tried, however much money they offered. Genoa had to make do, instead, with the so-called "white Pele", Almir. Coincidentally Santos took him home in 1963 to fill their No. 10 gap while *O Rei* (The King) was injured.

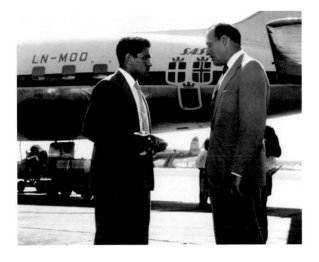

LEFT: A meeting on the tarmac between star footballer and star administrator. Garrincha (left) earned worldwide fame from his roles in Brazil's World Cup double in 1958 and 1962; Brazilian federation leader Joao Havelange achieved global power in football by capitalizing on the team's success to become president of FIFA.

BELOW: Pele drives for goal in the 1961 Tournoi de Paris at the old Parc des Princes. Santos beat newly-crowned European champions Benfica 6–3. Santos led 4–0 at half-time when Benfica brought on the young Eusebio – "the European Pele" – who scored a hat-trick. The next year Santos repeated their success over Benfica in the World Club Cup.

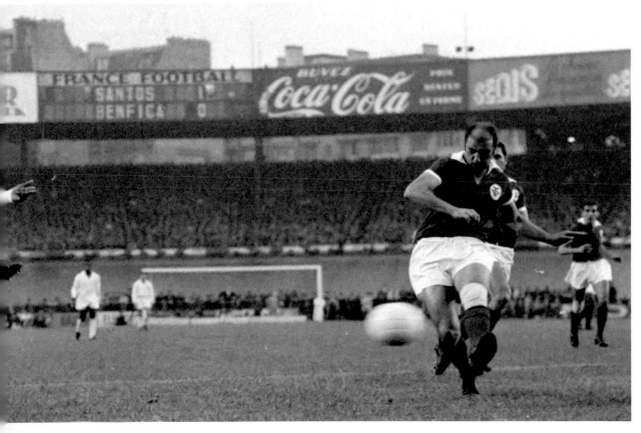

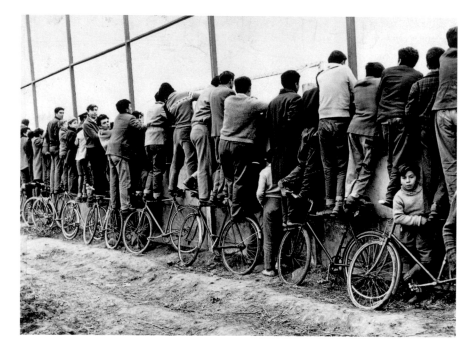

LEFT: Enraptured Chilean fans spy on their heroes in training before the hosts' 1962 semi-final against Brazil. Chile's achievement in ultimately finishing third was cathartic for a nation still recovering from the devastating effects of the 1960 earthquake in which an estimated 6,000 people died.

OPPOSITE: Police and officials escort Garrincha after he was sent off near the end of Brazil's victory over hosts Chile in Santiago in the 1962 World Cup semi-finals. However, Garrincha was not suspended for the Final as the match officials omitted to mention the incident in their report to the disciplinary committee.

Not every emigrant found success to equal that of Julinho or Jair. Vava lasted just two years at Atletico Madrid. The great Didi lasted only half that time at neighbours Real. The reigning European champions signed him amid great fanfare in the summer of 1959, but the writing was on the wall from the start. Alfredo Di Stefano, the world's greatest player and Madrid's "commander", supposedly welcomed Didi with the words: "They say you've come to replace me. Well, you're too old and you're not good enough."

Players such as Didi and Vava, by moving to Europe even briefly, capitalized financially to some extent on their prowess. Their team-mates were not as fortunate. There were no agents and managers to advise on investments, and bonuses were often wiped out by rampant inflation.

Years later, in preparing for the 2014 World Cup, parliament voted in a backdated pension for those first winning heroes who were still alive or for their relatives. In a very different football era fans were shocked to learn how some of their legends had died, almost forgotten, in obscurity and poverty.

In 1962 Didi and Di Stefano were on opposite sides in the World Cup in Chile. Brazil faced Spain in a concluding group match in Vina del Mar. Di Stefano was injured and could only watch as Brazil hit back from 1–0 down to win 2–1 and reach the quarter-finals. This was a stellar victory because they had achieved it without Pele.

The new king of world football had scored a superb goal in Brazil's opening win over Mexico, then pulled a thigh muscle in a 0–0 draw with Czechoslovakia. Not that Brazil noticed. His deputy, puckish little Amarildo, scored both the goals which sent Spain – and Di Stefano – home.

Brazil had a new coach. Vicente Feola, overweight and suffering from heart problems, had been replaced by Aimore Moreira. The new man had a family score to settle with the World Cup: his brother Zeze had been Brazil's coach in 1954 in Switzerland.

Team selection was a different "game" in those days. Substitutes were not allowed. Rotation was an unknown concept. Most managers' guiding principle was never to change a winning team.

Hence, for all the experimentation which had been undertaken after 1958, Moreira's starting line-up showed only two changes. Mauro took over from Bellini as captain and right centre-back, while Zozimo replaced Orlando as his partner. These were days, also, in which clubs were not obliged to release

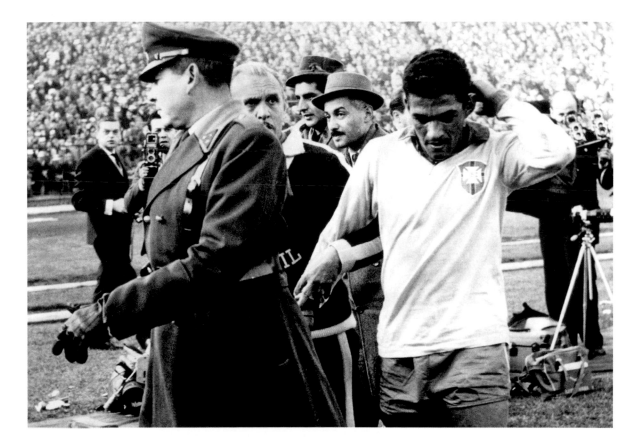

players for international matches: hence Orlando (Orlando Pecanha de Carvalho) was kept "prisoner" in Argentina by Boca Juniors.

Pele's absence threw the weight of creative invention on to Garrincha. He rose to the challenge magnificently, for all his wayward character. Discipline and Garrincha were never really compatible. He was a force of nature, practical joker, alcoholic, womanizer and a nightmare away from the pitch for any coach. A sort of Brazilian George Best. But out on the right wing, twisting full-backs inside out and back to front, he was without peer, then or since.

Garrincha had set up Amarildo's winning goal against Spain. That sent Brazil into a quarter-final against England. They won 3–1. Garrincha headed the first goal and struck the third with a long-range "banana" shot. It was another effort of his that bounced off keeper Ron Springett's chest to provide Vava with Brazil's second.

The goals were not the game's only interruption: play was held up at one point after a dog ran on the pitch. England forward Jimmy Greaves caught the dog and handed it over to an official; Garrincha later took it home as a pet.

By then he was a double World Cup winner, though not without controversy. Garrincha scored twice more in Brazil's 4–2 semi-final win over hosts Chile but was also sent off in the closing stages for lashing out after one foul too many by Chilean left-half Eladio Rojas.

Fortunately for Brazil and Garrincha, there were no automatic suspensions in those days. FIFA's

RIGHT: Centre-forward Vava leaps into the air in delight after scoring the third, and decisive, goal in Brazil's 3–1 defeat of Czechoslovakia in the 1962 Final in Santiago. Brazil thus won the World Cup for the second time in succession to equal Italy's feat in 1934 and 1938. Eight players appeared in the Finals of both 1958 and 1962.

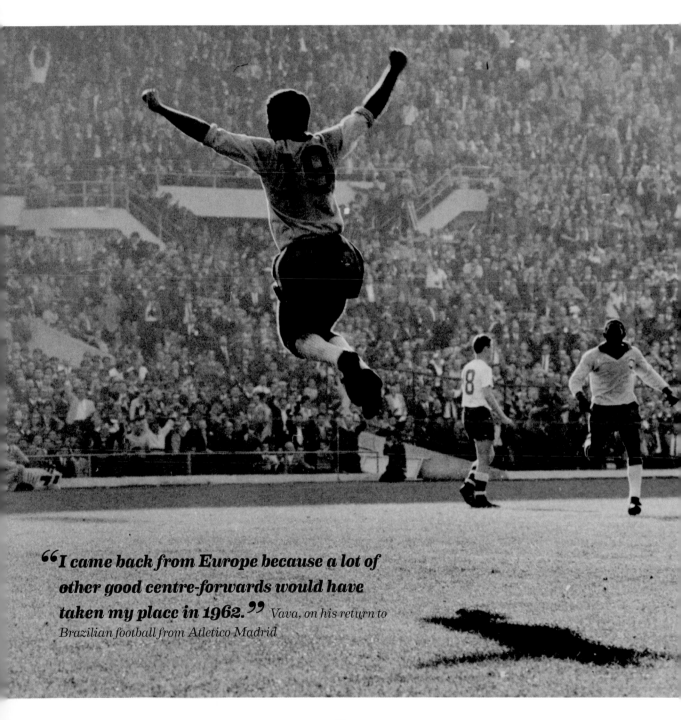

"I came back from Europe because a lot of other good centre-forwards would have taken my place in 1962." *Vava, on his return to Brazilian football from Atletico Madrid*

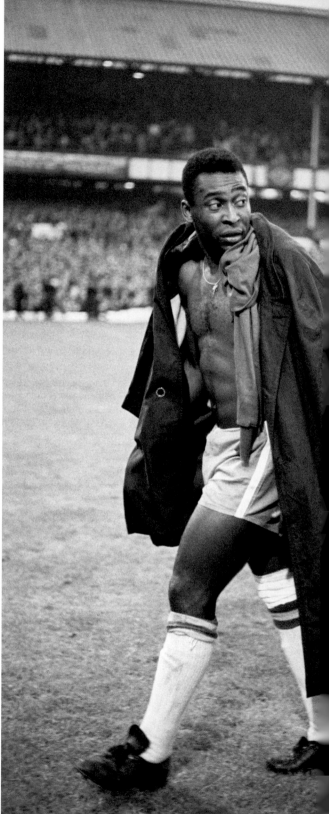

disciplinary committee, overseen by the world federation's English president Sir Stanley Rous, issued only a caution. This meant Garrincha was free to play the Final against Czechoslovakia, but he was suffering from a high temperature and contributed little.

Brazil, duly proving again to be anything but a one-man team, conceded an early goal to Jozef Masoput but ran out decisive 3–1 winners. Garrincha's irrepressible Botafogo club-mate Amarildo equalized; Zito and Vava both struck in the last 20 minutes.

Only Italy, in 1934 and 1938, had won the World Cup not only twice but twice in succession. Now the romance of the land of samba soccer had enchanted the world. In the next two years Santos were twice crowned world club champions. At a time when the club game in both Europe and South America was heading down a negative tactical cul-de-sac, here was proof beyond dispute that it was possible to play winning football which was also attractive and entertaining.

The pressure to freeze that moment in time proved too much to bear, however, when it came to chasing the dream of a third successive World Cup triumph in England in 1966.

Havelange and his CBD made a crucial mistake in sacking football director Paulo Machado and recalling 1958 boss Feola as coach … and Feola compounded the error still further by relying on no fewer than seven players from the Swedish glory days. Only Pele, at 25, was below 30. Gilmar was 35, Djalma Santos 37, Bellini 36, Orlando 30, Zito 33 and Garrincha 32.

Pele and Garrincha raised brief memories of happier days with the goals which beat Bulgaria at Goodison Park, Liverpool. But Pele was also injured and three days later, without him Brazil were outplayed by Hungary on the same ground. The 3–1 loss was Brazil's first World Cup defeat since the Battle of Bern, also against Hungary, in 1954.

Panic set in. Feola made nine changes for the win-or-bust group climax against Portugal. The Portuguese, managed by a Brazilian in Otto Gloria, hacked away mercilessly at the half-fit Pele under the benevolent supervision of English referee George McCabe. He was lost to the game before half-time, but by then Portugal were already 2–0 ahead and on their way to a 3–1 success.

Brazil and quarter-finals losers Argentina and Uruguay all flew home to South America railing against the iniquities of having been ambushed in a European World Cup by rough, tough European players aided and abetted by lenient European referees. Basically, in Brazil's case, they had forgotten, in their complacency, the original lesson of 1958: thorough preparation with nothing left to chance.

FAR LEFT: Pele was an inspiration to club and country not only because of his talent but also because of his lack of ego. This meant that he trained as hard if not harder, than any of his team-mates with Santos and Brazil. His supreme physical fitness meant that, despite harsh treatment from opponents, he also suffered remarkably few serious injuries.

LEFT: The saddest sight at the 1966 World Cup was an injured Pele leaving the pitch at Goodison Park, Liverpool, after Brazil's 3 1 defeat by Portugal. Pele, only half-fit after an earlier injury, was harassed mercilessly by the Portuguese and limped out of the game before half-time. Brazil lost 3–1. This was the last World Cup where substitutes were not permitted.

❝ *After my death, I'd like people to say I was [a] good man who always tried to bring people together and maybe also that I was [a] good footballer.* ❞

Pele, on being voted Player of the Century in 1999

Brazil operated, at that time, after the manner of most other South American football federations. A national coach was appointed for a specific tournament or a tour, not signed up to a lengthy contract with a World Cup target away in the distance. Hence Aimore Moreira was coach in 1967, then Dorival Yustrich in 1968. Chaos reigned. Brazil went on tour to Europe and Central America and were beaten by West Germany, by Czechoslovakia and by Mexico twice, the second time – almost unthinkably – in Maracana.

Havelange, still in charge and now under pressure as never before, went back to basics. He made his peace with Paulo Machado, who returned to the CBD and created a national technical committee. This, in turn, appointed Joao Saldanha as coach.

Havelange and Saldanha were poles apart: the successful sportsman turned businessman and every politician's ally teaming up with the openly avowed communist. Saldanha was an intriguing mix himself. A failed youth player, he had later coached Botafogo – his battles of wits with Garrincha were hilarious and legendary – then turned to journalism. Indeed, it may have been because of Saldanha's work that Havelange approved the appointment, hoping to garner an easier ride from a highly critical media.

"Our Brazilian football, at its very best, is a creation which demands the best musical accompaniment." *Joao Saldanha, Brazil manager during the 1970 World Cup qualifiers*

Brazil won all six of their World Cup qualifying ties, home and away, against Paraguay, Colombia and Venezuela. They scored 23 goals and conceded two. Job done. But then Saldanha spoiled it. He left Pele out of a friendly game against Chile, talked airily about not relying on him for the World Cup and squabbled publicly with government ministers over team selection.

When state President Emilio Garrastazu Medici called for the selection of Atletico Mineiro centre-forward Dario, Saldanha snapped: "He can pick his Ministers, but only I pick the Selecao." Another time, after goalkeeper Manga sneaked out of the team hotel, a furious Saldanha chased after him waving a revolver; the Botafogo goalkeeper vaulted a wall to make a petrified escape.

Havelange dissolved the national technical commission and, thus, Saldanha along with it. In February 1970, four months before the World Cup finals in Mexico, the 1958 and 1962 winning winger Zagallo was appointed.

Five months later Zagallo was also being hailed as the first man to win the World Cup as player then manager. His Brazil proved magisterial at the finals: each performance was surpassed by the next. Group victories over Czechoslovakia, England and Romania were followed by a free-flowing 4–2 dismissal of a fine Peru side in the quarter-finals, a highly focused 3-1 execution of old enemy Uruguay in the semis and then the 4–1 apotheosis against Italy in the Final.

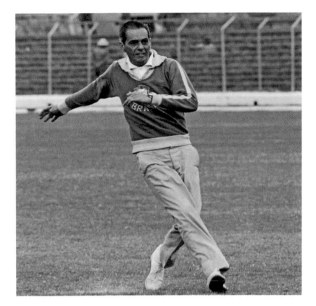

LEFT: Joao Saldanha, one-time player and journalist, was the coach originally appointed to prepare Brazil for the 1970 World Cup finals and the attempt to regain the Jules Rimet Trophy. However, Saldanha was sacked and replaced by Mario Zagallo just before the finals began after falling out with politicians, football officials and even some of his players.

BELOW: The World Cup comes to Mexico for the first time with the teams of the Soviet Union and Mexico lining up before kick-off at the climax to the formal Opening Ceremony in the Estadio Azteca. Both would lose in the quarter-finals, the Soviets against Hungary and their Mexican hosts against eventual runners-up Italy. The 1970 World Cup was brought to life with colour television, gloriously showcasing the talents of the Brazil team.

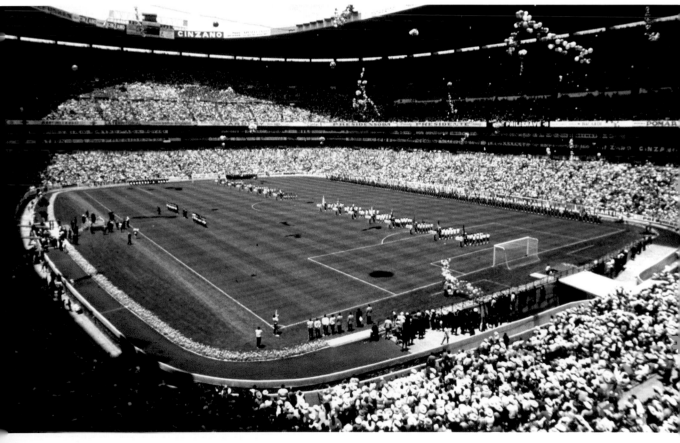

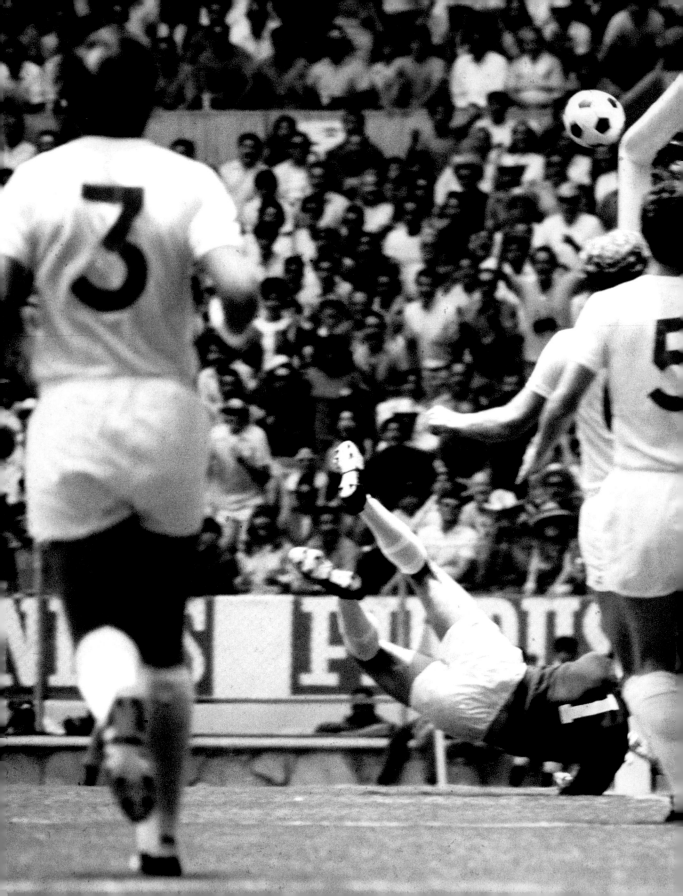

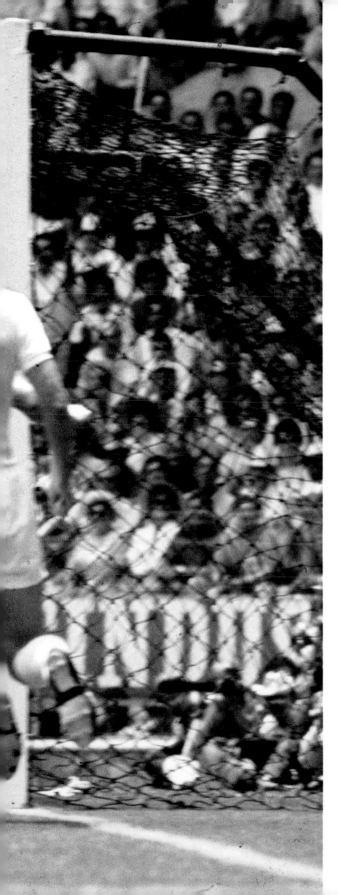

Television seared the images into world football's memory for all time: Pele's attempt at a goal from half-way against Czechoslovakia; his amazement at being foiled by goalkeeper Gordon Banks and then his gladiatorial exchange of shirts with Bobby Moore against England; his "wrong-side" dummy around keeper Ladislao Mazurkiwicz in the semi-final; Jairzinho scoring in every game; Pele's inevitable opening goal against Italy ... and his selfless creative role in the thunderous masterpiece of a fourth by skipper Carlos Alberto.

This was, indeed, the Beautiful Game, the *Jogo Bonito*, samba soccer: the World Cup and international football in its greatest glory – a pinnacle never matched before or since.

At least, this is what the mind-bending medium of television was able to insist. The 1970 World Cup was a unique event. This was the first finals tournament televised in colour and the first which benefited from the global exposure now available through the technological miracle of satellite transmission.

Brazil were a great team playing great football in a great competitive setting: from Carlos Alberto through to Gerson and Roberto Rivelino in midfield and on through Jairzinho, Tostao and Pele in attack. But their style, impact and achievement were enhanced by the new televisual wizardry.

The least that could be said of such an "honour" was that no World Cup-winning team deserved it more than Brazil.

LEFT: England goalkeeper Gordon Banks pulls off the "save of the century". Brazil's Jairzinho closed in on goal from the Brazilian right, then crossed to the far post. Pele appeared certain to score as he rose for a close-range header, but Banks threw himself back across the goal-line to turn the ball around the post for a corner.

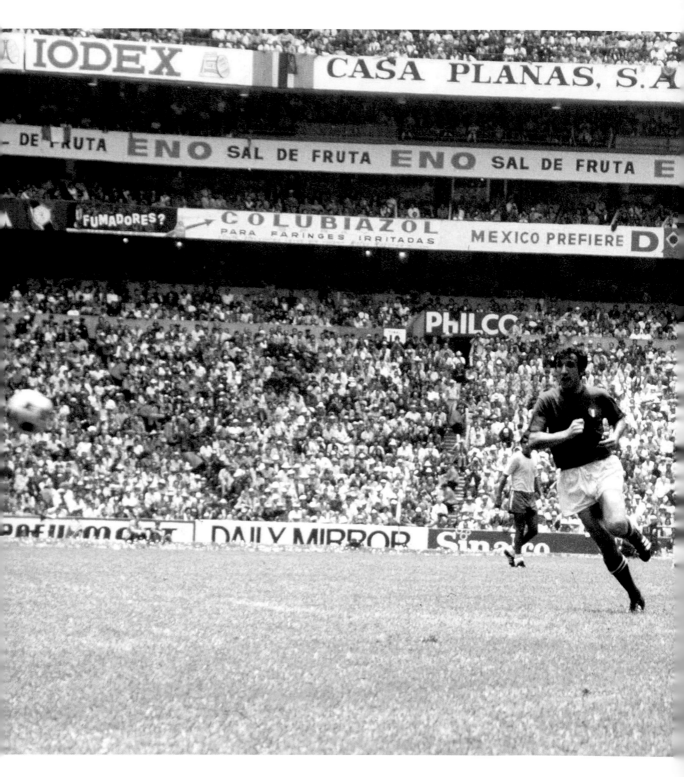

ABOVE: Brazilian centre-forward Tostao is stripped of his kit by acquisitively delirious fans during the celebrations of the 4–1 defeat of Italy in the 1970 World Cup Final in Mexico City. Tostao had starred despite having earlier been in danger of missing the entire tournament because of eye problems.

LEFT: Midfielder Gerson thunders home the crucial second goal with which Brazil regained the lead over Italy at 2–1 midway through the second half of the 1970 World Cup Final in the Estadio Azteca. Earlier Pele had put Brazil in front only for Roberto Boninsegna to equalize after punishing a defensive mistake.

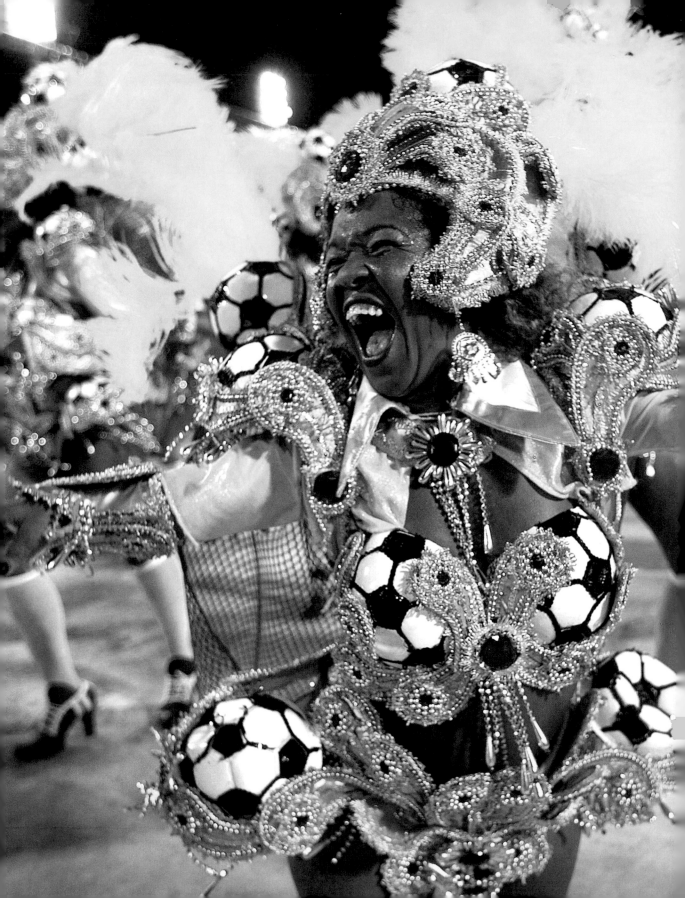

Chapter 4
CARNIVAL TIME

Every nation is victimized or blessed by its caricature. For some nations this is overwhelmingly bleak; for some unrealistically positive; for some blatantly unfair. Brazil is one of the latter. This is a nation which is not, as popular imagery would have it, all about football, coffee and samba.

This is hardly negative, of course, as images go. But today's Brazil would prefer to be taken rather more seriously while maintaining that reputation for enjoyment of life, whenever the strains and stresses of the modern world permit.

Hence the colonial grandeur of central Rio de Janeiro is balanced by the industrious high-rise clutter of Sao Paulo, and the country's climate veers giddily from the steamy humidity of Amazonia in the north-west down to the warming refreshment of Rio Grande do Sul.

All of which creates the personality compound which the rest of the world thinks of as the flavour of Brazil and its people, largely thanks to the vibrancy of the fans who follow the Selecao to the World Cup every time – and "every" is significant since a factor offering reason for arrogance is Brazil's unique status as the only nation to have played at every World Cup finals tournament since its inception next door, down south in Uruguay.

Fans everywhere now flaunt similar uniforms in their colour: the team shirt, the headband, the wristlet and the face paint. Perhaps Brazilian fans stand out through the vivid yellow and green.

Beyond inspiring the trappings of loyalty, no other national team possesses Brazil's magnetic power to galvanize the expatriate community and bring a unique flavour to the fan zones with a kaleidoscope of colour, costume and samba rhythms.

LEFT: A dancer from the Unidos do Viradouro samba school illustrates perfectly, and joyously, the delight taken by Brazilians in mixing their passions for football and music – both of which can be highly competitive. The schools vie to exceed each other in the vibrancy and creativity of their fantastical costumes.

The national team's arrival anywhere from Brussels to Beijing is an irresistible invitation – an order, even – for the diaspora to flaunt its national pride in a context where Brazil rules the world (whatever the prevailing dynamics within global politics, finance, commerce, industry, etc).

After all, until lately very, very few Brazilians could even dream of following the Selecao beyond Rio or Sao Paulo or Salvador or Belo Horizonte.

But understanding the innate passion and identity of the *torcida* (fans) also depends on understanding where Brazil and Brazilians came from, in the first place, within a continental land mass which fell, otherwise, to the Spanish conquistadores.

Communities of nomadic and semi-nomadic Indians roamed the eastern swathe of South America at least 8,000 years ago according to anthropologists and historians. In 1494 Spain and Portugal settled a notional, north-to-south dissection of South America. Six years later, one of the great seafaring Portuguese navigators, Pedro Alvares Cabral, was blown off course to the coast of what is now the state of Bahia.

BELOW: The Rio carnival, in its early days in the 1930s, was a far more restrained local parade than the exhibitionist, international event it would ultimately become. In those days participants were more aware of the religious significance of the timing, just before the start of the 40 days of Lent.

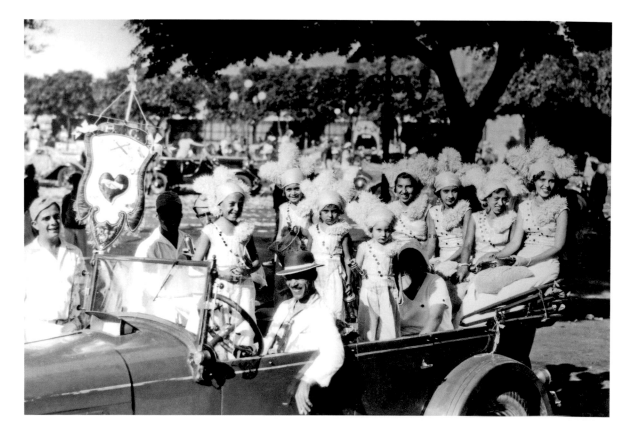

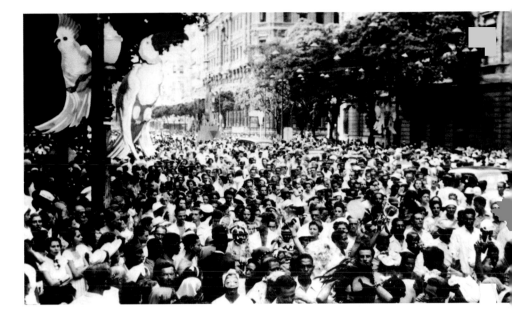

RIGHT: Samba styles evolved along with carnival. By the 1950s the Blocos de Rua – the street carnival bands – had become an intrinsic feature not only of the main event but in each and every neighbourhood. The bands, varying in size and each with its distinctive name, provided mesmeric leadership for the "block parades".

Cabral named the haven as Porto Seguro and claimed the land for Portugal. The name Brazil came from the brazilwood tree whose timber Cabral shipped home for both the hardwood and the dye which could be extracted from it.

The original explorers – the *Bandeirantes* – spread inland after the unification of Spain and Portugal in the late sixteenth century. Portuguese influence grew stronger after King Joao IV reclaimed the crown in 1640. Commercial exploitation of sugar and coffee plus mining for gold and diamonds attracted more immigrants before Crown Prince Pedro declared Brazil's independence on September 7, 1822. He duly proclaimed himself Emperor Pedro I.

In 1889 his son, Pedro II, was ousted when Brazil became a republic. In 1960, Rio de Janeiro, Pedro's capital, was ousted in status by Brasilia under the presidency of Juscelino Kubitschek. The purpose-built city in the Brazilian Highlands owes its presence in UNESCO's World Heritage List to the futuristic architecture of Oscar Niemeyer.

By this time the Brazilian demographic had also changed. From the earliest days of discovery, African slaves were imported in vast numbers to work the sugar and coffee plantations. Slavery was not abolished until 1888, by which time their presence had been established in Brazilian culture through music, food and religion.

> **"What's great about carnival time is that it's a chance for every single Brazilian to be one of the stars of the show."** *Ronaldo, World Cup-winning striker, in 2002*

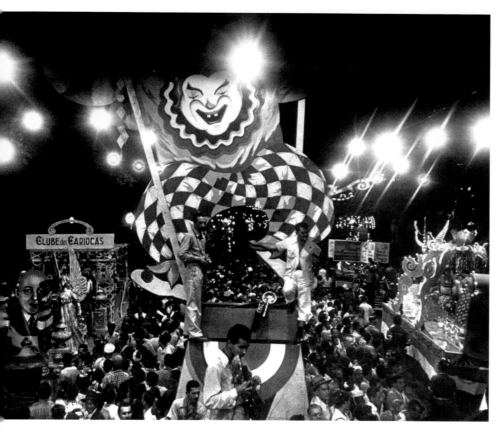

ABOVE: At times the carnival parades in Rio de Janeiro evolve into the equivalent of a giant conga as parades sway and dance past each other in opposite directions on the main avenues from the Sambodromo and on down past the seafront beaches.

RIGHT: The relationship between World Cup-winning hero Garrincha and revered samba singer Elza Soares caused a scandal in the early 1960s, since he had a wife and seven children at home. The couple were subsequently married for 14 years before Garrincha died of alcohol poisoning in 1983.

Samba – that quintessential evocation of Brazilian exuberance and football's own national heartbeat – evolved from Angolan and Congolese circle dances. In the first 20 years of the last century, as football was exploding on the national psyche, so was dance with the launch of the first samba schools. These "escolas" now form the heart of the iconic Rio Carnaval (though samba is far from being exclusive to Rio).

Carnaval, to give it its Portuguese name, is a five-day explosion in early February of noise, colour, music and outrageous pageantry and now entrances a television audience of billions. Thousands of dancers and entertainers parade through the 70,000-capacity Passarela Professor Darcy Ribeiro, better known as the Sambodromo. This is a spectator-lined chicane through which the entertainers parade. More than a dozen such "sambodromes" exist in Brazil, but the most iconic remains the Rio version which was designed by Niemeyer himself and opened in 1984.

The sheer spirit of exhibitionism which unites fantastical costume and rhythmical music sets an entertainment standard which football fans love to see translated on the football pitch. This is why individuals down the years from Heleno to Ronaldinho have been worshipped in Brazil while pragmatic observers – usually European – treat the individualism with some disdain.

Football and carnival boast a historic connection. The first samba schools' parade, in 1930, was supported, promoted and sponsored by the newspaper *Mundo Sportivo* which was owned and run by the noted sports journalist and author Mario Filho. Carnival went from strength to strength and inspired similar celebrations in Sao Paulo (in 1935), in Porto Alegre (1961) and across the length and breadth of the nation.

Just as samba evolved down the years by an intermix with every other style and influence from American jazz to reggae, so did the national social character and football along with it. Indeed,

it could be suggested that football helped lead the way. Certainly it offers the most obvious example of Brazil's integrationist progress into what the sociologist Gilberto Freyre defined as a nation "not ashamed of its Amerindian, Jewish and African basic elements but proud of them".

Association football in its British homeland, for all its evolution into the "people's game", was organized and codified by the upper classes in their universities and so-called "public" schools. Similarly in Brazil and, especially, Rio. Horse racing was the sport of the court during the monarchy, and then came the upper classes' cycling and rowing clubs, out of which football clubs grew.

For upper and middle classes, also read "white". The original football clubs had no place for a *mulato* (child of white and black parents) or a *mestico* (child of a European and Indian parents).

The first non-white to break through into Brazil's nascent national team was the legendary Artur Friedenreich, son of a German immigrant businessman and a black former slave laundress. The journalist Mario Filho described him as "a mulato with green eyes". Never mind the colour of his eyes. It was the German name which opened the path of Fried into a white football world.

In 1919 he was one of only two non-whites to play for Brazil in the Copa America and also scored the winning goal in the final match.

Fluminense did not sign a non-white player until 1914. Even then the newcomer, Carlos Alberto, felt so self-conscious that, according to club mythology, he sprinkled his hair and face with rice powder. This did not fool fans of America, his former club. They greeted him with jeers of "po de arroz". Fluminense fans duly adopted the label with pride and began the custom of throwing rice powder as their team entered the pitch before a game.

Not until professionalism was embraced formally in the early 1930s by the Brazilian game did Flamengo line up a black player. A good one, too.

Left-winger Jarbas Batista went on to score 154 goals in 300 games, ranking him still among the club's all-time top 10 marksmen. Within a few years Flamengo were led by two of the greatest black players in Brazilian football history: centre-forward Leonidas (the "Black Diamond") and full-back Domingos da Guia.

Bangu had been the first Rio team to line up a mixed side. This owed everything to the club's origin as a sports club for employees of the textile mills of the Compania Progresso Industrial to the west of the city. Most of the players were British but, since they worked alongside mulattos and blacks, they had no compunction about playing football together.

Even more upsetting for the traditionalists was Vasco da Gama's victory in the 1923 Carioca championship, because it was accomplished by a team made up of mostly blacks and illiterate labourers. They were paid sometimes with money, sometimes with meat and other provisions. Beaten, furious rivals such as Flamengo, Fluminense and Botafogo founded a new federation from which

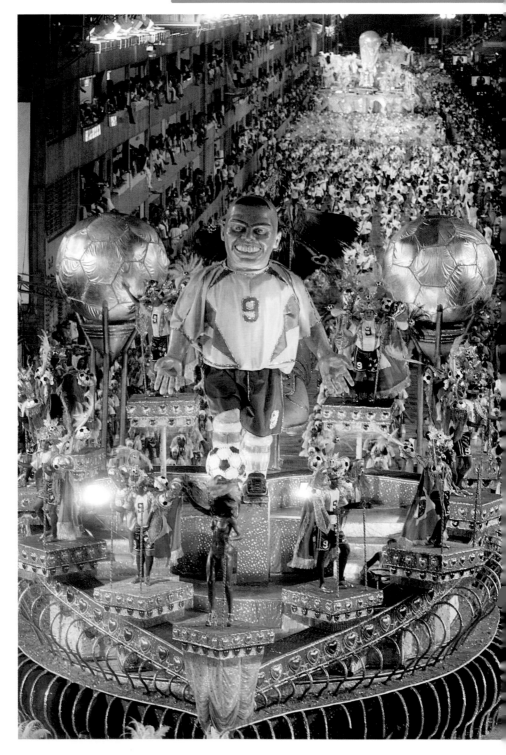

RIGHT: Ronaldo, in giant effigy, loomed large over the 2003 carnival celebrations on one of the most extravagant of the floats, with models kitted out in the national team kit amid the golden football decorations. Up to five million spectators, half a million from abroad, turn out to enjoy the week-long party.

OPPOSITE: Ronaldo, nine-goal leading scorer when Brazil won the World Cup in Japan and South Korea in 2002, also knows what it is like to be star of the show at the Rio carnival. His "prize" of a crown and costume was far more flamboyant than the "mere" gold medal he was given to wear around his neck in Yokohama.

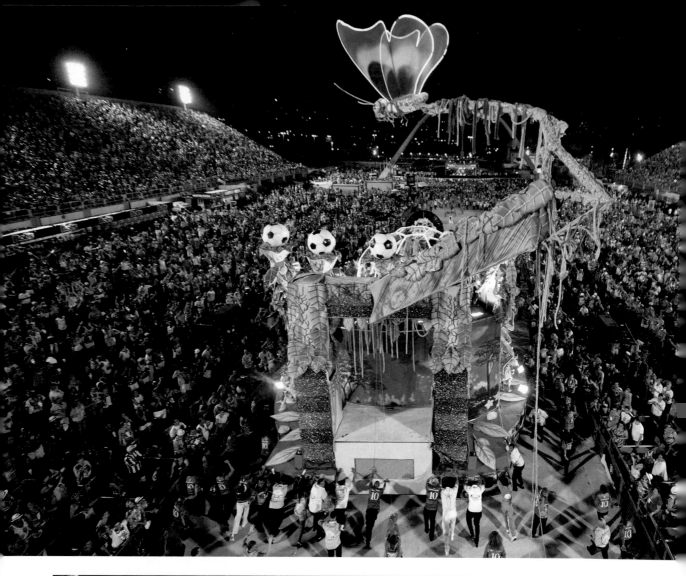

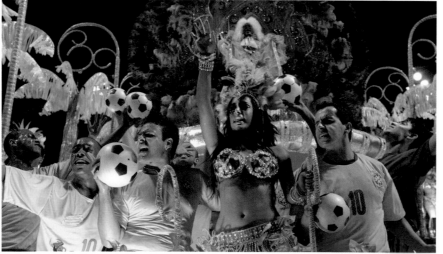

LEFT: Anyone who is anyone appreciates the value of a high-visibility role in carnival – and not necessarily in Rio de Janeiro. Every city across Brazil is proud of its own event, and here in Sao Paulo a starring role is being taken by Paraguayan model Larissa Riquelme along with revellers from the Unidos de Vila Maria school.

ABOVE: A perfect perspective of the Sambodromo in Rio de Janeiro with the passing performers for the 90,000-plus crowd coming from the Mangueira samba school. The 700m-long Marques de Sapucai parade arena was designed by the great Brazilian revolutionary architect Oscar Niemeyer and opened in 1984.

> **❝Brazilians know how to enjoy themselves and we promise all our visitors will do that when they come for the World Cup.❞** *Orlando Silva, Brazil's former Minister of Sport*

Vasco were excluded on the spurious grounds that they did not have a stadium to call their own.

After one year with two rival leagues a truce was signed and a major victory had been achieved over football racism.

Integration was equally awkward elsewhere. In Sao Paulo, for example, the various expatriate communities had their different clubs – British, German, Portuguese, Italian and even Roman Catholic and Protestant. The walls started to come down only during the First World War when sons of the expat families travelled back to Europe to enlist. Most never returned. Such an evolutionary tale is common to the football history of Brazil's other great cities.

Hence, in the late 1950s, when Europe's old powers were trying to come to terms with immigration from their own old colonies, Brazil turned up at the World Cup in Sweden with a team of whites, mulattos, mesticos and blacks. One of those blacks would also prove to be one of the greatest personalities in sporting history: Pele.

Years later he would set a further trend as the first black government minister when he was handed the sports portfolio. In 1998 he introduced the so-called "Pele law" modelled on the "Bosman verdict" of the European Court of Justice. This sought to balance the contractual rights of clubs and players but has had much less of an impact than its European cousin, having been steadily watered down by the clubs.

All of this has not affected the passion of fans of both sexes for the men's game. Dramatic evidence of the status of the Selecao as the proud, representative face of the nation was delivered in decibel-busting fashion at the 2013 Confederations Cup, the warm-up tournament for the country's hosting of the World Cup.

Street protests and demonstrations had erupted across the nation as millions turned out to complain about what they considered inequitable state spending on World Cup facilities compared with social welfare. Yet the Selecao's role as a symbol of national unity was explosively demonstrated before both the semi-final against Uruguay in Belo Horizonte and the final in Rio at Maracana.

LEFT: Brazil's footballers have always taken their music with them around the world. In the case of Robinho (left) and Alex Silva in Maracaibo, Venezuela, in 2007 the beat proved a footballing hit: four days later Brazil beat Argentina 3–0 in the final of the Copa America.

On each occasion the massed capacity crowd not only sang the national anthem with power and commitment but insisted on singing all the verses to a conclusion rather than stop with the formal 90-second stadium recording. Coach Luiz Felipe Scolari and his players sang on as well and later hailed the inspiration they drew from the crowd as a factor in both eventual victories.

Scolari had declared, on returning as national coach the previous November, that one of his prime missions was to "reconnect our nation with our team". He believed that too many disappointments since his own team's World Cup triumph in 2002, allied to excessive publicity about millionaire wages and lifestyles, had driven a wedge between players and people.

Now, despite events outside the stadia, unity had been restored between the Selecao and the torcida. Just as the Olympic movement proclaims its ambitions to be "faster, higher, stronger", so Brazil's football fans might proclaim an aspiration for unity, passion and glory. A powerful image indeed.

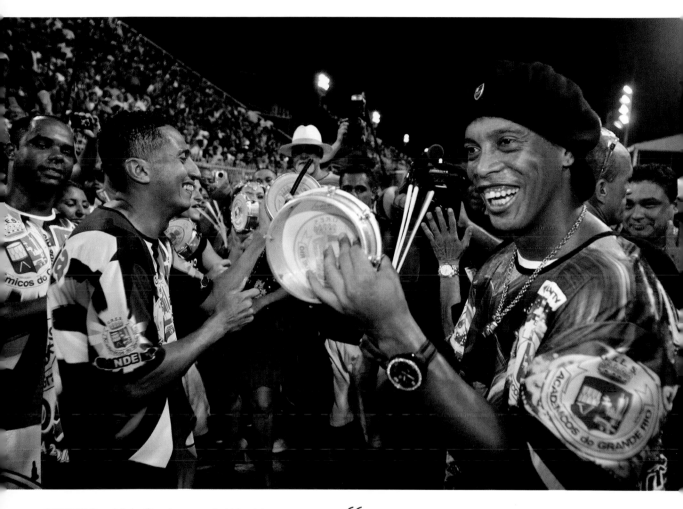

ABOVE: Ronaldinho Gaucho cemented his status as a people's hero when he turned up unannounced for rehearsals with the Academicos do Grande Rio samba school in the Sambodromo before the Rio carnival in 2011. He further delighted fans by joining in with the Portela school on the one day and Academicos the next.

"People say I like to party. Yes, I do. So do most people and, in Brazil, we have the best parties in the world." *Ronaldinho, one of the most popular of players at carnival time*

RIGHT: Brazil's *torcida* (supporters) dance to the beat of the samba in Belo Horizonte before Brazil's defeat of Uruguay in the 2013 Confederations Cup semi-final. Meanwhile, on the other side of the Estadio Mineirao, riot police were holding back demonstrators protesting over World Cup expenditure.

BELOW: Many Brazilian clubs are complex sporting, social and cultural organizations of which football is one section, albeit a highly important and visible one. Here Santos supporters' Sangue Jovem samba school take to the stage during the club's centenary celebrations in 2012.

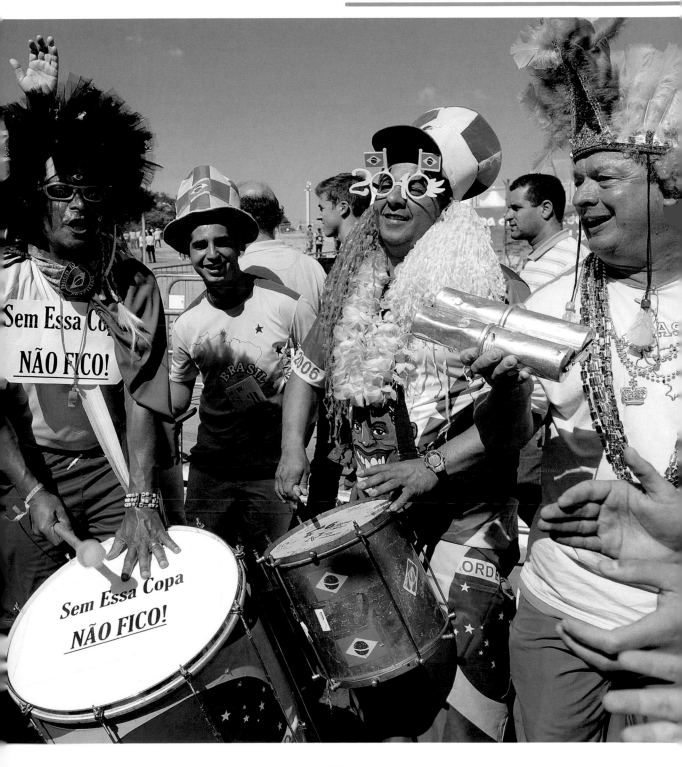

Chapter 5
AND THE BEAT GOES ON

The unforgettable moment when Carlos Alberto Torres thundered Brazil's climactic fourth goal beyond Enrico Albertosi in the 86th minute of the 1970 World Cup Final in the Estadio Azteca in Mexico City should have been the start of an era – with Brazil launched forward into an exemplary reign as kings of world football.

The vision at the time was of an even more skilled and entertaining repetition of the near-eight-year domination between 1958 and 1966: from the victory over Austria in Uddevalla to the moment just before kick-off against Hungary at Goodison Park, Liverpool.

Instead of an upward evolution, however, the outcome was a downward spiral.

Pele had had enough of World Cups. He had seen what happened when his old team-mates from 1958 and 1962 had tried to stretch their careers too far: the slow disintegration of talent and technique. He had no intention of sullying his own reputation that way.

In the meantime he could continue to play on for Santos and there were more than enough demands on him from sponsors, politicians, fans and prospective business partners – some honourable, too many dishonourable – to fill his time.

Mexico had provided the stage for a unique World Cup. To suit European television times, many of the games had kicked off in the heat of the day; the slower pace had suited the Brazilians, Peruvians and Uruguayans and the heat had burned the legs off the English, the Germans and the Italians.

RIGHT: Paulo Roberto Falcao was one of a dozen Brazilian players who graduated to national manager. For all his achievements, the most memorable moment enshrined in World Cup history was his goal against Italy in 1982 after a body swerve which, according to one commentator, "sent even the goalposts the wrong way".

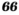

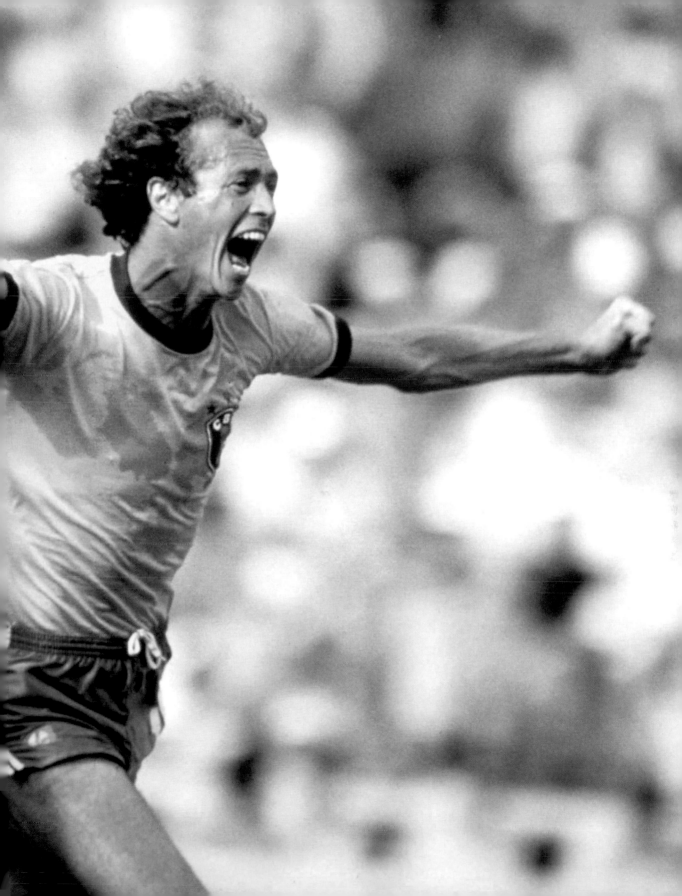

No such World Cup would come around again for a very long time. Hence the future of the finals, for anyone who cared to see, would be about greater tactical sophistication and an all-round game which balanced the values of both technique and physique.

One year later, while Brazil was still celebrating permanent possession of the historic Jules Rimet Trophy – named after the FIFA president who launched the World Cup – Dutch club Ajax from Amsterdam won the European Champions Cup at Wembley. As significant as the result was the manner in which they achieved it: Ajax were developing a style to become known as "total football". It demanded the two factors which set the foundation for the next 40 years: a new level of physical fitness combined with high technical skill, and all applied at pace of both mind and muscle.

Around the same time Joao Havelange, having guided Brazilian football since January 1958 as president of the CBD, took his eye off the domestic ball. Havelange, impatient with the patrician style of the Europeans who thought it their right to dictate the world game, intended to become the first non-European president of world federation FIFA.

Meanwhile Brazil's clubs, on the international stage, ceded power for the next decade to Argentina in the Copa Libertadores.

Zagallo was the one unifying force. He stayed on as national team manager through to the World Cup finals in West Germany in 1974. Only Jairzinho and Roberto Rivelino made the journey with him. Luis Pereira – nicknamed Chevrolet – was an outstanding new central defender with a powerful attacking bent, and Francisco Marinho a marauding left-back whose daring was as striking as his shoulder-length mane of blond hair.

But none of this was sufficient to match the development within the European game. The goalless draw against Yugoslavia with which Brazil opened the finals was a disappointingly accurate foretaste of what was to come. Next time out they drew 0–0 again against Scotland. Only a hard-

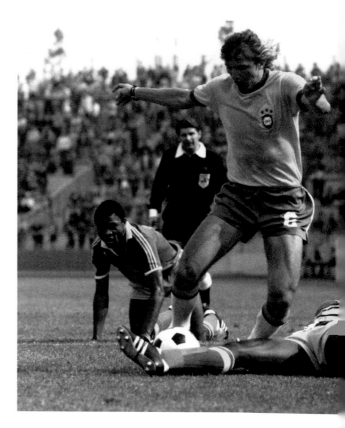

ABOVE: Francisco Marinho skips between two tackles in Brazil's 3–0 win over World Cup newcomers Zaire at the 1974 finals. Marinho was a raiding left-back in the Brazilian tradition and was one of the outstanding individual performers in West Germany, where Brazil finished fourth after losing the "places play-off" to Poland.

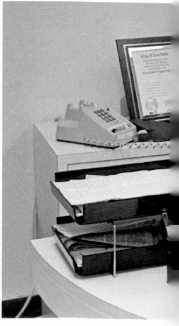

> **"Brazil let their face slip: they did not come out to take part in a football match against us but in a war."** *Rinus Michels, coach of Holland after beating Brazil 2-0 in the 1974 World Cup*

BELOW: Pele's fame led to huge demand on his time as a player, as a personality and as a businessman. Not all his commercial ventures proved profitable. This was one of the reasons why he was drawn to conquer the United States with Cosmos of New York, despite having retired already from the Brazilian national team.

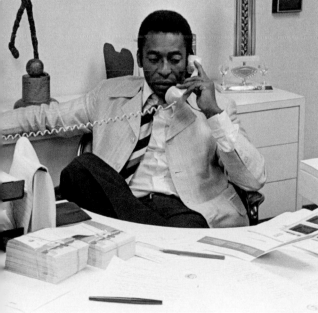

worked 3–0 win over out-of-their-depth debutants Zaire edged them into the second round on goal difference; Jairzinho and Rivelino scored two of the three goals.

At this point Brazil's hopes of holding on to the crown remained alive. Another goal from Rivelino earned victory over East Germany in their second-round group, and both he and Jairzinho were on target in a 2–1 win over Argentina. But that was the end of the road for the world champions.

The decisive group game was lost 2–0 to Holland, and Brazil were fortunate to escape so lightly. A capacity 53,700 crowd in the new Westfalen Stadium in Dortmund saw a strange reversal of roles with Brazil trying strong-arm tactics to negate Dutch skill. This time Jairzinho and Rivelino were not enough. Johan Neeskens and Johan Cruyff struck in the first 20 minutes of the second half, and the game, top spot in the group and a place in the Final were all lost long before Luis Pereira was sent off in the closing minutes.

Brazil lost the third-place play-off to Poland and flew home to a torrent of abuse and recrimination. Zagallo, predictably as manager, had to shoulder much of the blame. But he had sought merely to make the best of a squad which was a chasm apart in terms of character, talent and personality from the 1970 squad.

At least Brazil had one success to hail: Havelange had skilfully networked off the back of his record of success as head of Brazilian football to oust Sir Stanley Rous as president of FIFA. Significant help in corralling votes had come from the politically savvy Horst Dassler, scion of the Adidas sportswear empire. Within a matters of years the two of them would create a template for television

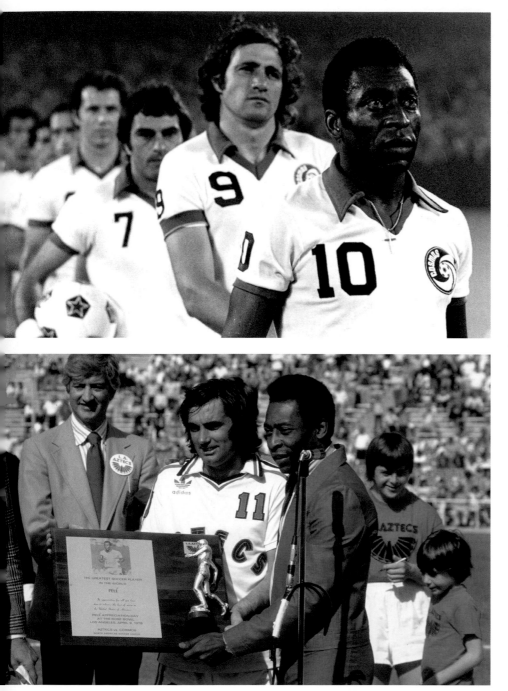

LEFT: Pele put soccer – a word coined originally by founders of the game in England in the late nineteenth century – on the map in the United States. New York Cosmos spent heavily on veteran stars who also included Italy's Giorgio Chinaglia (behind Pele), West Germany's Franz Beckenbauer and Pele's fellow Brazilian World Cup-winner Carlos Alberto Torres.

BELOW: Cosmos were not the only club to bring imported glitz to the over-ambitious North American Soccer League in the 1970s. Former Manchester United and Northern Ireland idol George Best (centre) lined up with Los Angeles Aztecs, Fort Lauderdale Strikers and San Jose Earthquakes between 1976 and 1981.

and sponsorship which would revolutionize not only world football but world sport.

Havelange would command FIFA for the next 24 years and his influence endured far beyond his formal retirement in 1998: in 2007 his son-in-law Ricardo Teixeira was the Brazilian federation president who secured host rights to the 2014 World Cup; then, in 2009, Havelange made the keynote address which persuaded the International Olympic Committee to award the 2016 summer Games to Rio de Janeiro.

Having run domestic business for 17 years, from January 1958 until January 1975, Havelange stepped down as president of the CBD and left Heleno de Barros Nunes to sort out the crisis of the national team. Not that Havelange remained aloof. In September 1979, using his authority as head of FIFA, he ordered the CBD to reorganize itself and create a single-sport Confederacao Brasileira de Futebol (CBF). Nunes duly followed orders and then retired himself, four months later.

In fact Nunes had no option but to retire after shouldering some of the blame for Brazil's World Cup failure in 1978. This was possibly even more painful than 1974. At least then the Selecao had the excuse of playing in Europe on European terms. In 1978 they were "next door" in Argentina and, even worse, Argentina won the Cup in circumstances which no Brazilian will ever accept.

Zagallo had stepped down as manager after the 1974 failure and was replaced by another "old

" *Joao Havelange had promised once not to stand against me but the South American federation persuaded him.* **"** *Sir Stanley Rous, ousted by Havelange as FIFA president*

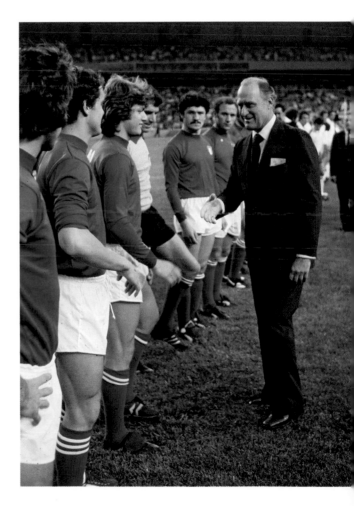

RIGHT: Joao Havelange expanded his power base from Brazil to the world after becoming president of FIFA in 1974. Two years later his duties involved greeting these Italian players and their English opponents before their match in the United States' Bicentennial Cup. England won 3–2 in the unusual football setting of Yankee Stadium, New York.

guard" coach in Oswaldo Brandao. Before the 1978 World Cup, however, the CBD decided that a new, modern, more scientific approach was needed.

Hence the appointment of a former army physical training expert, Claudio Coutinho, as national coach. Known as "Capitao", after his army rank, Coutinho had been fitness coach under Zagallo in Mexico in 1970. Educated, erudite, a linguist, Coutinho was the coach who introduced the new "Cooper Test" into Brazilian football fitness regimes.

On leaving the army he worked with the Peruvian national team, Vasco da Gama, Brazil again in 1974, then French club Marseille. In 1976 he was rushed in as coach of the Brazilian football squad heading for the Montreal Olympics. Brazil finished fourth and Flamengo, at his players' urging, appointed him to his first senior club job.

Within months, and with very little elite experience, he found himself entrusted with the national team heading for the World Cup in Argentina.

Coutinho was a Europhile in football terms. Against every Brazilian footballing precept, he believed in the team ethic above individualism. That

ABOVE LEFT: Claudio Coutinho introduced a new approach to fitness and tactics as manager of Brazil at the 1978 World Cup in Argentina, but that did not always go down well with players and presidents. He claimed Brazil were "moral winners" after a controversial conclusion to the climactic stage of the tournament.

ABOVE: One of Zico's greatest performances was in inspiring Flamengo to their World Club Cup victory over Liverpool in Tokyo. Liverpool's Ray Kennedy, Graeme Souness and Alan Hansen (above) were unable to cope with Zico's brilliance, which was too much for them, especially after an 18-hour flight and on a bone-hard pitch.

did not go down well with the players. He dropped Paulo Roberto Falcao, Brazil's finest extrovert midfielder, and failed to devise a system which suited both Zico and Reinaldo, the country's two most gifted new strikers.

Indeed, he even dropped Zico for a decisive group game against Spain. Only one of the worst open-goal misses in the history of the World Cup, from Spanish midfielder Julio Cardenosa, spared Brazil defeat. A 3–0 win over Austria edged them into the second-round group stage.

At this point CBD chief Barros Nunes stepped in. He told Coutinho to drop both Reinaldo and Zico and rearrange the defence. The result was an improved performance and a 3–0 win over Peru. A host of chances for more goals went begging; that failure to score more would come back to haunt Coutinho.

The finals had been set up as in West Germany in 1974. The winners of the two second-round groups would meet in the final; the runners-up would play off for third place.

After the first matchday Brazil led Argentina, 2–0 winners over Poland, on goal difference. That remained the situation after the second matchday in which Argentina and Brazil drew 0–0 in Rosario. Everything depended on the last matchday.

This was where the suspicions began. The last two matches in the two groups were scheduled for the same day. Group A's concluding ties (Austria 3, West Germany 2 and Holland 2, Italy 1) both kicked off simultaneously at 13.45 local time. But TV reportedly insisted that Brazil v Poland should start at 16.45 and then Argentina v Peru at 19.15.

Hence Brazil wrapped up a 3–1 win over Poland two hours before Argentina kicked off against Peru, knowing they needed to win by a four-goal margin to reach the final. That margin was attained by five minutes into the second half. Argentina ended up 6–0 winners to the tearful fury of the Brazilian players and their fans.

Stories persist, despite all the denials, that Peru's players had been leaned on to throw the match by their own government, for political and trade reasons. Eventually Brazil finished third after a 2–1 play-off win over Italy and left for home soil believing that they were, as Coutinho put it, "the moral champions".

Coutinho learned from the experience. He returned to Flamengo, made his peace with Zico, brought through the attacking left-back Junior, and laid the foundations of a magnificent club side. In 1981 they celebrated Brazil's first success in the Copa Libertadores in five years and they went on to play Liverpool off the pitch in Tokyo in the World Club Cup. Sadly Coutinho did not live to see it. He had died in a scuba-diving accident 16 days earlier.

Zico and Junior and some of their Flamengo team-mates were going on from strength to strength now, at last, with the national team.

RIGHT: Brazil were still winding up their forces when they met Scotland in the 1982 World Cup finals. They had beaten the Soviet Union "only" 2–1 in their first game, then went a goal down early on against the Scots. Zico's celebration expresses both relief and delight at his equalizer. Brazil went on to win 4–1.

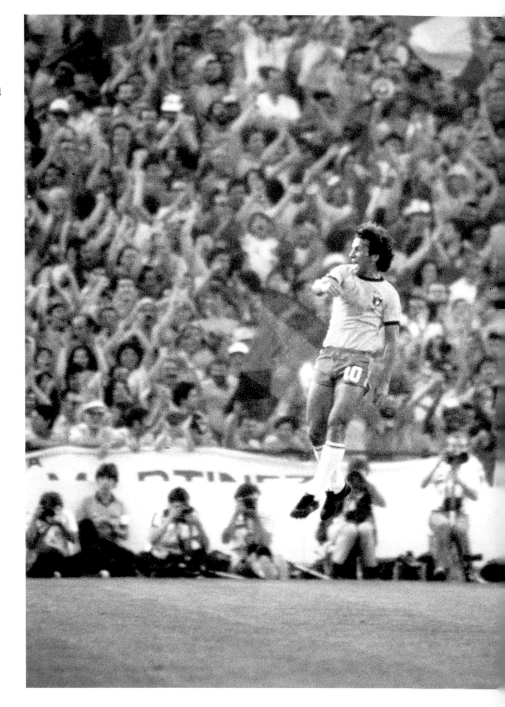

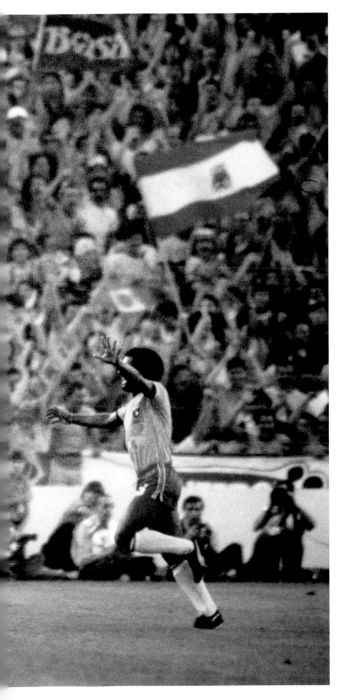

Change was under way in both the nation and its football. No longer were footballers merely seen on the pitch and heard in the sports programmes: now they were also speaking on issues beyond the pitch. Most outstanding of all was Socrates Brasileiro Sampaio de Souza Vieira de Oliveira – known simply as Socrates, or "Doutor" after his professional medical qualification.

Socrates was not merely one of the most gifted attacking midfielders ever to play for Brazil – and Botafogo, Corinthians, Italy's Fiorentina, Flamengo and Santos – but one of the game's most outstanding humanitarians. He was a political activist on and off the pitch, and it was a sad irony that a man who had so much to offer his sport should die young, at only 57.

By then he had long been a legend of the worldwide game. Much of his status was due to his eye-catching presence on the pitch combined with his leadership of Brazil in the World Cups of 1982 in Spain and 1986 back in Mexico.

The team which played in Spain glittered once more with Brazilian stardust courtesy of Socrates, Zico, Junior, Falcao, centre-forward Roberto Dinamite and left-winger Eder. They all benefited from a manager in Tele Santana who encouraged their attacking instincts. The Soviet Union were beaten 2–1, Scotland swamped 4–1 and New Zealand swatted 4–0.

The result was a place in Barcelona's Sarria stadium in a "group of death" if ever there was one, comprising Brazil, Italy and holders Argentina with

> **Why we didn't win in 1982 is a mystery. We had such a fantastic team. It's one of those things beyond all understanding.**
>
> *Paulo Roberto Falcao, Brazilian midfielder*

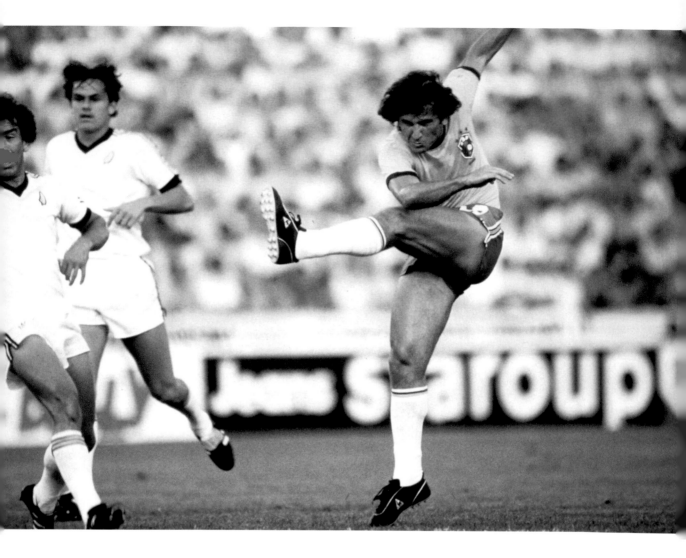

their new superboy in Diego Maradona. Brazil were not in any mood to let this young upstart challenge their brilliance. He was sent off and Brazil won 3–1. Junior set off on a memorable samba dance of delight down the pitch after scoring the third goal.

Thus Brazil now faced Italy with a place in the semi-finals at stake. A draw would have been enough. But, of course, with Brazil – and this Brazil in particular – playing for safety was out of the question. The outcome was one of the most memorable matches in the history of the World Cup.

Poor defending saw Italy grab an early lead through Paolo Rossi, the centre-forward who had only just returned to action after a two-year match-fixing ban. No problem. Brazil had trailed, after all, against the Soviets. Zico eluded tough-tackling Claudio Gentile and moved the ball on for Socrates to equalize.

ABOVE: Zico strikes one of his two goals in Brazil's 4–0 thrashing of New Zealand in Seville in the first-round group stage of the 1982 finals. Many Brazilian fans consider this the finest team not to finish as World Cup winners. That assessment owed less to four wins and 14 goals in five games than to a flamboyantly positive style of play.

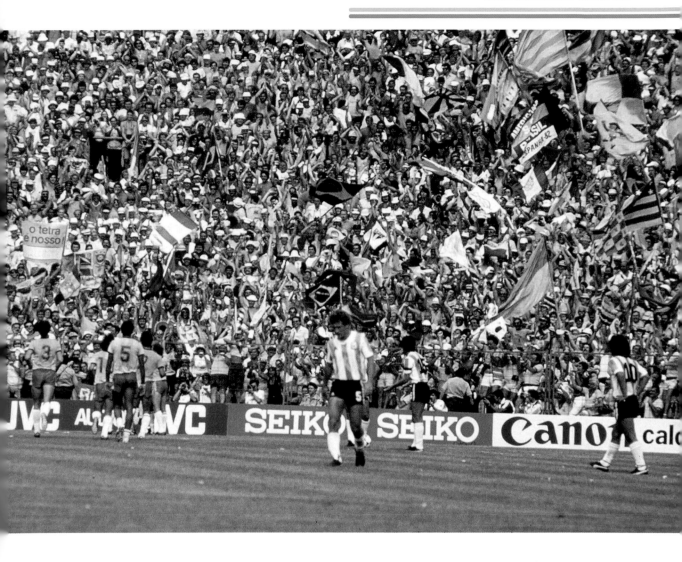

ABOVE: Fans have always found ways to defy organizers' attempts, down the years, to prevent them bringing flags into the stadia. When Junior scored Brazil's third goal against Argentina in Barcelona in the second round in 1982, a forest of Brazilian flags rose high just as the Argentinian banners dropped to half mast and then out of sight altogether.

More poor defending and Rossi had put Italy back ahead. Deep into the second half Falcao sent the entire Italian defence the wrong way with a feint on the edge of the penalty box and thrashed home a second equalizer. Brazil, to all intents and purposes, were in the semi-finals.

Unfortunately, the team who knew better than any other how to attack did not know how to defend. They continued to forge forward while Santana sat in the dugout with a worrying premonition. Rossi completed his hat-trick at one end, Dino Zoff made an acrobatic save from Brazilian defender Oscar at the other ... and it was all over.

Italy went on to beat West Germany in the final, winning their third World Cup in the process. Brazil flew home still baffled and bemused at how they let the World Cup escape them. "I think we would have been very worthy winners,"

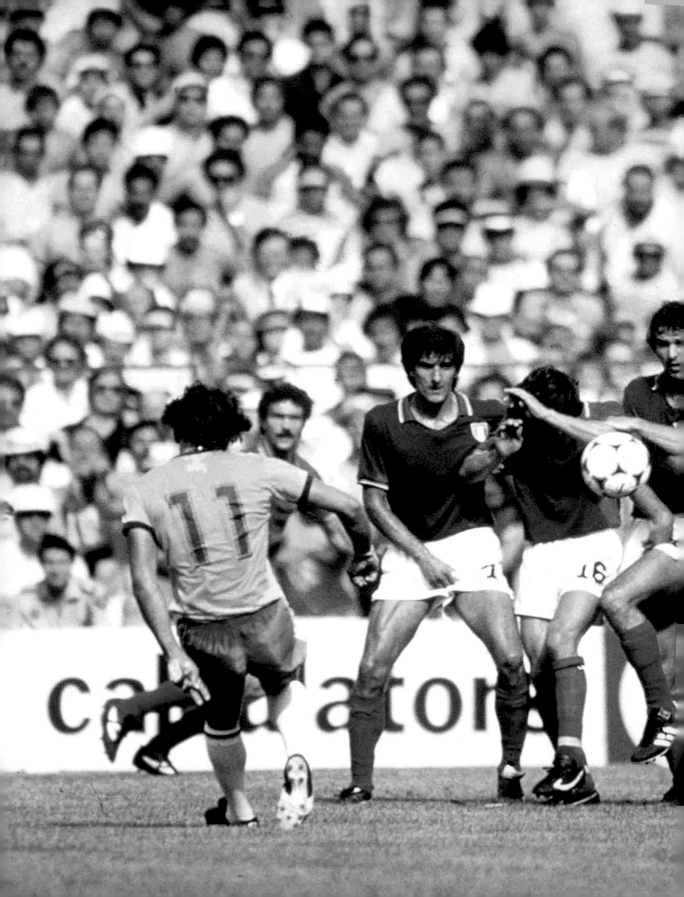

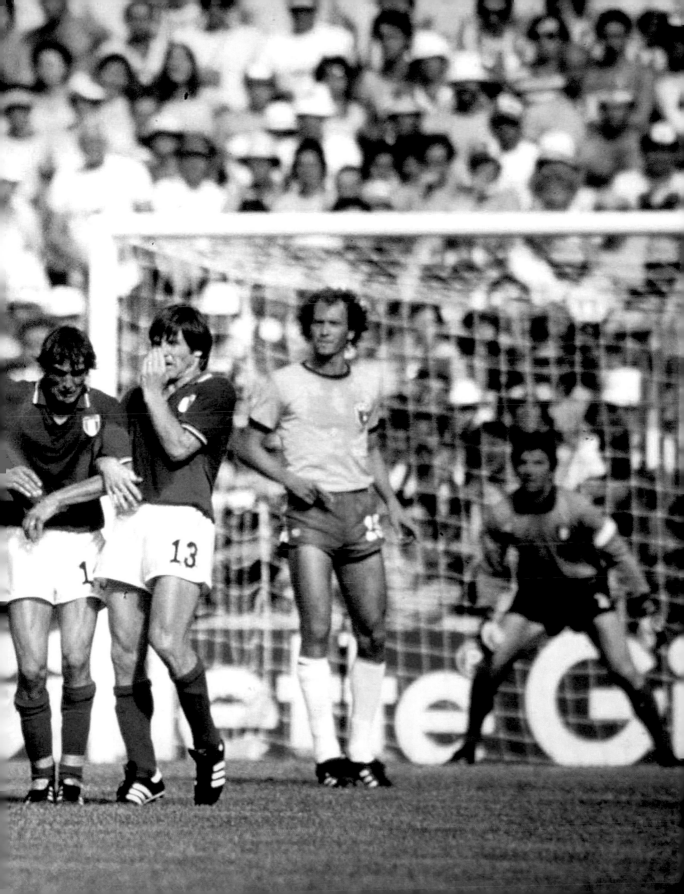

PREVIOUS PAGE: Left-winger Eder was renowned for possessing one of the most powerful dead-ball shots in international football, but this free-kick failed to produce a goal against Italy in Barcelona. Brazil hit back twice from a goal down but ultimately lost 3–2 as Italy ended their World Cup dream for another four years.

BELOW: Left-back Paulo Cesar Magalhaes of Gremio (right) outjumps Hamburg's Ditmar Jakobs in the 1983 World Club Cup Final in Tokyo. Success for the Porto Alegre club demonstrated the depth of talent within the Brazilian game beyond the traditional football centres of Rio de Janeiro and Sao Paulo.

RIGHT: Celebration time for Josimar after the right-back thundered home a goal from 30 metres for Brazil against Northern Ireland at the 1986 World Cup finals in Mexico. Brazil won 3–0 to top their group and earn a second-round clash with Poland which saw Josimar on target again in a comprehensive 4–0 victory.

said Santana. It's true to say that most of the rest of the world agreed with him.

The Brazilian domestic game remained the powerful foundation of the World Cup effort. Only two of the 22-man squad were playing with foreign clubs: Falcao at Italy's Roma and fellow midfielder Dirceu with Atletico de Madrid in Spain.

Stars such as Socrates, Zico and Roberto Dinamite went home to demand better governance in the Brazilian club game. Socrates, at Corinthians, led a movement demanding that players and coaches should all have a right to vote on major decisions, including contracts, and that married players should be spared joining "ritiro", where the team withdraws into seclusion, away from family, the night before a match.

Weeks before the World Cup the CBF had agreed to permit clubs to sell advertising space on their shirts for the first time. The financial health of the Brazilian club game appeared assured for years to come.

Thus Flamengo, Corinthians, Sao Paulo and the rest could afford wages to match top clubs in Europe. In 1986, as in 1982, only two foreign-based players featured in Santana's World Cup squad: captain and full-back Edinho, who was playing in Italy with Udinese, and Junior, also in Italy, with Torino.

Brazil were as much favourites in 1986 as they had been in Mexico 16 years earlier. Same attitude and a similar core of elite talent – such as Zico, Socrates and Junior – but with a more secure defence and a fine new centre-forward in Careca.

The trick, with any World Cup, is to start steadily and evolve from game and game. Brazil did precisely that. Spain were beaten 1–0; so were Algeria. Next Northern Ireland were defeated 3–0: in the latter victory right-back Josimar beat veteran goalkeeper Pat Jennings with one of the most powerful drives imaginable.

The format of the finals had been changed yet again. The second round was no longer a group format but direct knockout. Brazil raised their game still further to see off Poland 4–0 and thus found

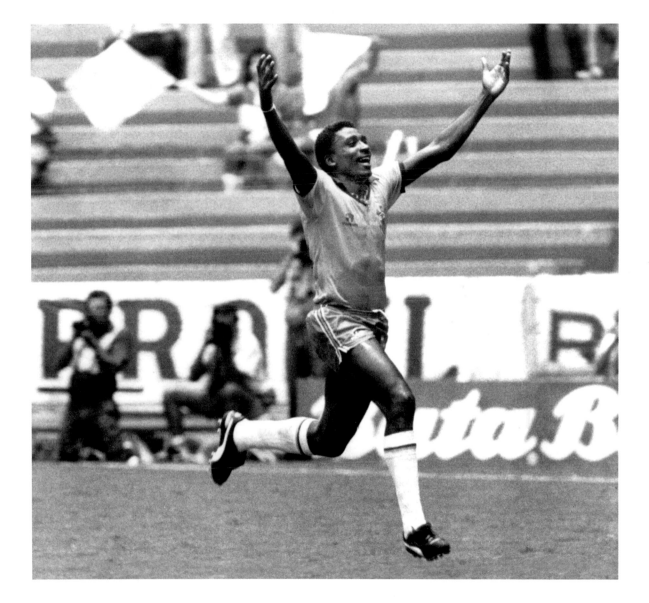

" It was as if you were with the most beautiful woman in the world but could not do anything with her. Sometimes, life is like that. "

Socrates, looking back on the 1986 World Cup

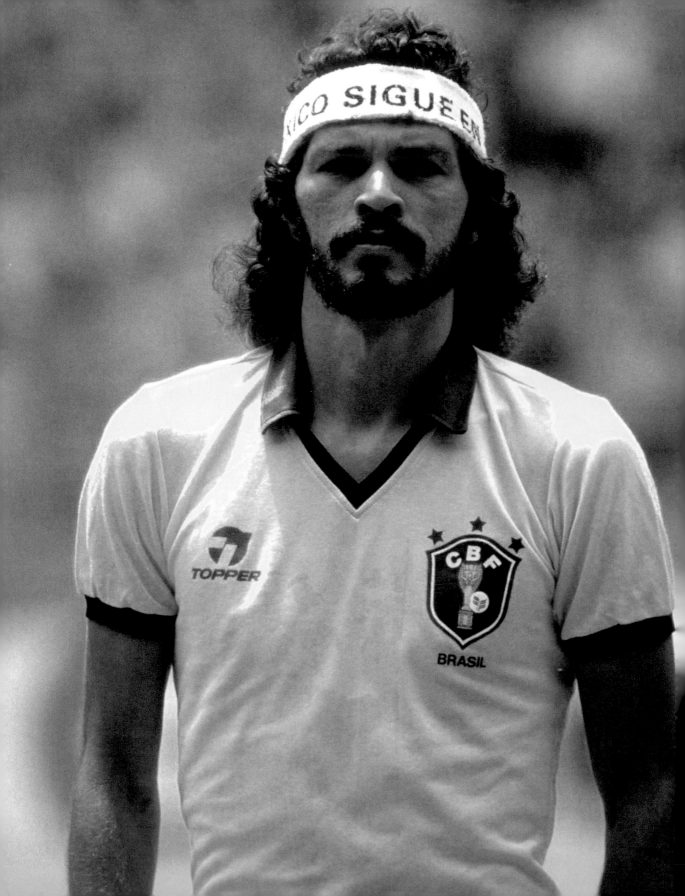

LEFT: Socrates Brasileiro Sampaio de Souza Vieira de Oliveira was not merely one of Brazil's finest players in the 1970s and 1980s but one of the country's great personalities. A medical doctor, political activist and agitator for players' rights, Socrates scored 22 goals in 60 internationals and was voted South American Player of the Year in 1983.

themselves facing European champions France in the quarter-finals.

Santana's only doubt concerned Zico. Now 33, the Flamengo star had been injured shortly before the finals. Santana had used him sparingly as a substitute against Northern Ireland and Poland and put him on the bench again in the quarter-final. No matter. Careca gave Brazil an early lead. But then French captain Michel Platini equalized four minutes before the interval.

Midway through the second half, considering the French defenders to be tiring, Santana sent on Zico to take advantage. Everything ran according to plan. Within minutes left-back Branco burst into the French penalty box and was brought down by keeper Joel Bats. Nowadays Bats would not only have been penalized with a spot-kick but would have been sent off. But not then. Thus he got up, walked back to his line and awaited the penalty.

Socrates was the designated penalty taker but he offered the shot to Zico as an encouragement to his half-fit team-mate. Wrong decision. Zico shot weakly and Bats saved.

The game went to extra time and then a penalty shoot-out. Socrates, ironically, failed with the first. Platini shot over the bar the one which would have won it for France but Julio Cesar missed and Luis Fernandez shot Brazil to defeat. They were not alone: Mexico and Spain were also beaten on penalties. Only Argentina, courtesy of both the mischief and magic of Maradona, won their quarter-final outright against England.

Brazil, having won the World Cup three times in four tournaments, had now endured the painful embarrassment of a further four without success.

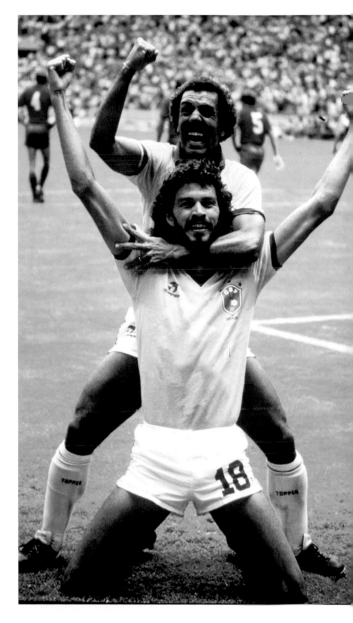

ABOVE: Socrates and team-mate Junior face the fans – and the photographers – to celebrate his lone, winning goal against Spain at the start of the 1986 World Cup adventure in Mexico. He also scored against Poland in the second round but was out of the luck in the quarter-finals ...

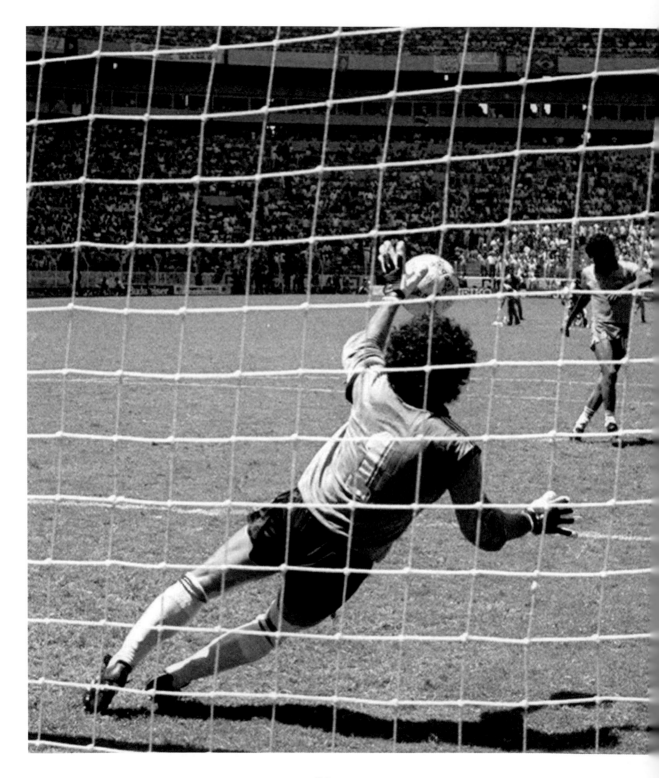

LEFT: The beginning of the end for Brazil as France goalkeeper Joel Bats saves a penalty from Socrates in the 1986 quarter-final. The teams had drawn 1–1 and this was the first kick of the shoot-out. Bats said later: "I knew which way to go because I watched the way he took his penalty before against Poland." Brazil lost the shoot-out 4–3.

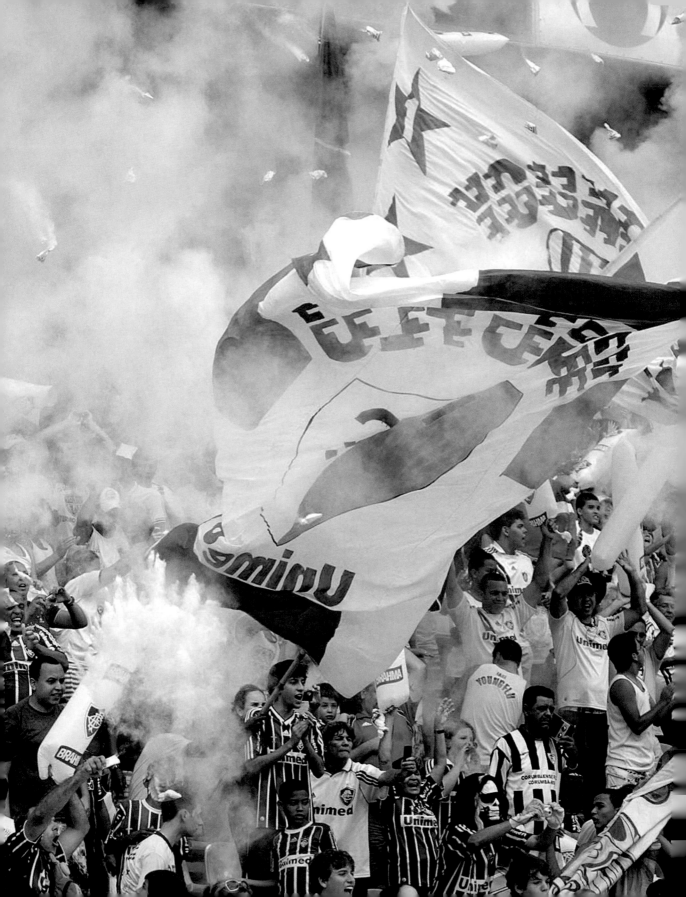

Chapter 6
TRIBAL GATHERINGS

An Olympic Games gold medal is the only mainstream football prize to have eluded Brazil. Otherwise the march of both the national team and the nation's favourite clubs across not only the continent of South America but the entire world has placed Brazil at the apex of the game – whatever the statistical ups and downs of the world federation's computerized ranking system may indicate from one month to another.

Brazil's list of honours is headed by a record five World Cups. Then follow eight age-group world trophies plus eight Copa America titles. At club level it lays proud claim to 10 more world titles, 17 victories in the Copa Libertadores (South American equivalent of the UEFA Champions League) and 12 in other assorted continental competitions which have come and gone down the years.

No other country can compare in terms of breadth and depth. Consider Brazil's demographic range. The land mass of 8.5 million sq km is fifth in the world behind Russia, Canada, the United States and China and a population of 193 million is also fifth behind China, India, the US and Indonesia. By all counts Brazil by far outstrips Argentina, England, France, Germany, Holland, Italy and Spain, which might be considered the other seven members of world football's elite.

Yet its football power is based largely on the strength of a mere six of the country's 27 regions and 16 of its clubs.

Football's historical development everywhere in the world has gone hand in hand with industrialization. Hence the size of the clubs is linked with the expanding power of towns and cities in terms of population, employment and hence a magnetic attraction away from the rural regions. More than 80 per cent of Brazilians live in urban areas.

LEFT: Fluminense's fans, with their "powder guns", flares, banners and chants, are as colourful as the green, white and maroon colours on which the club settled in the early 1920s. The "po de arroz" (rice powder) nickname was adopted after a *mulatto* player named Carlos Alberto covered his face with powder to disguise his skin colour back in 1914.

A top 10 of the largest cities is headed by Sao Paulo (population 11 million) followed by Rio de Janeiro (6 million) and includes Belo Horizonte (2 million), Curitiba (1.7 million), Recife (1.5 million) and Porto Alegre (1.4 million). These are also the cities with the greatest clubs. Their status and popularity as expressed in terms of memberships are beyond the dreams of most European clubs.

Because Brazil is in the southern hemisphere the football season is organized on a calendar basis, as in most of Africa and much of Asia. The close season runs during the summer months from the start of December to the end of January.

In the early years of the Brazilian domestic game the sheer size of the country and associated travel difficulties meant that competitions were organized on a city and state basis, unlike in Europe where smaller countries meant national club competitions became the norm from the inter-war years onwards (except in Germany).

> **"When I die I want to be buried wearing my Cruzeiro shirt because that will guarantee me eternal life."** *A post on Cruzeiro's Mafia Azul fans' website*

A national championship was not created until the end of the 1960s. Now the state championships take up the first five months of the year and the national

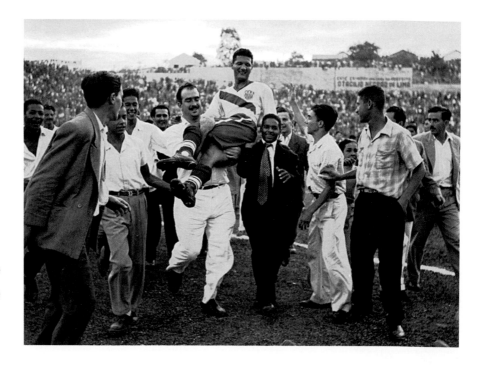

RIGHT: United States match-winner Joe Gaetjens is carried away by delighted fans after the 1–0 defeat of England in Belo Horizonte in the 1950s finals. Ballboy Elmo Cordeiro later recalled: "We thought of England as the kings of football so we were delighted the Americans won, because we thought that now it would be easier for Brazil to win the Cup."

ABOVE: The balloon goes up ... as Cruzeiro of Belo Horizonte take to the pitch for a derby against Atletico Mineiro in the Minas Gerais state championship in February 2013. The club had switched to blue shirts – as a gesture to their emigrant ancestry – after being forced by anti-Axis laws in the early 1940s to drop their original name of Palestra Italia.

tournament takes up the rest. The Copa do Brasil is staged in the first half of the year without those clubs tied up in the South American club tournaments.

Brazilian fans may also be considered as more fickle than their European counterparts. Until recent years reliable crowd statistics were few and far between, but the success and failure of a club had a heavily significant effect on attendances, unlike in Europe where the season-ticket system has maintained crowd levels on a steadier basis.

In Brazil a minimum GDP meant ticket prices had to be kept low, but the construction between the 1950s and 1970s of enormous, municipally owned stadia such as the Mineirao in Belo Horizonte (originally 130,000) and Morumbi in Sao Paulo (originally 140,000) kept gate receipts comparatively high.

One of the great questions against the legacy of the World Cup will be the effect of the new, redeveloped, lower-capacity, all-seater stadia. Ticket prices will have to rise steeply and, while Brazil's domestic wealth is also on the rise, balancing the books may become even more problematic.

This may be more of a challenge in Rio de Janeiro and Sao Paulo than in other football centres such as Belo Horizonte, Porto Alegre and, to a lesser extent, in Recife and Curitiba. The reason is that a glance through the roll of honours illustrates all too clearly that Rio and Sao Paulo are the only two cities who boast more than two powerful clubs.

Football in Belo Horizonte, in the state of Minas Gerais, is all about Atletico Mineiro and Cruzeiro; in Porto Alegre, in Rio Grande so Sul, the monopoly is shared by Gremio and Internacional; in Recife, in Pernambuco, Sport and

ABOVE: The Estadio Mineirao in Belo Horizonte was one of the first stadia whose redevelopment was completed ahead of the 2014 World Cup. That meant the stadium, owned by the state of Minas Gerais, was one of the few ready in good time for the 2013 Confederations Cup. The three matches it hosted included this semi-final in which Brazil defeated Uruguay 2–1.

"Players didn't exchange shirts back then. They just took them off and sent them for washing for the next game." *Elmo Cordeiro, ballboy at the USA v England 1950 World Cup match in Belo Horizonte*

Nautico are the big two clubs nowadays; in Curitiba, in Parana, the split is between Coritiba and Atletico Paranaense.

The remaining 21 states – including the Federal District which incorporates Brasilia, Oscar Niemeyer's personalized capital – all have their state championships and state football federations with a voice and a vote in the Confederacao Brasileira de Futebol. This political influence endows them with a status beyond their football strength and offers a clue to the pressure which forced FIFA to drop its original plan to organize the 2014 World Cup groups in regional clusters. The cities' political and sporting leaders – often the same individuals – demanded equal rights to host all the top teams and had the political leverage to do so.

The enduring strength of football in certain states and cities is also illustrated by the fact that Rio, Sao Paulo, Belo Horizonte, Porto Alegre, Recife and Curitiba were the six host cities for the 1950 World Cup and all are included on the 2014 schedule.

Belo Horizonte was where England, notoriously, lost 1–0 to the United States in 1950. The old Estadio Independencia has been rebuilt – though the famous 'goal' end is still open – and is home to America Futebol Clube which won 10 state championships in a row between 1916 and 1925. The coming of

professionalism in the 1930s, however, saw America pushed back to third in the local pecking order behind Atletico Mineiro and Cruzeiro.

This is now the great rivalry in both city and state. Atletico were founded in 1908 with the aim of throwing open sporting opportunities to young people from all strata of society, unlike other local clubs. Initially the major derby matched Atletico against America, but as the latter hit hard times so Cruzeiro (founded 1921) took up the gauntlet.

Cruzeiro had been founded in 1921 as Societa Sportiva Palestra Italia by rebellious Italian members of the local Yale Athletic Club; they were compelled into the name change by anti-Axis laws during the Second World War.

Also in the 1940s graphic artist Mangabeira (Fernando Pieruicetti, a cartoonist with the local *Folha de Minas* newspaper) was commissioned to create mascots for all three local clubs. His original designs may be viewed still in the football museum in Belo Horizonte: a fox (raposa) for Cruzeiro, a rabbit for America and a cockerel for Atletico.

The images stuck firm and Atletico are commonly known across city, state and country as "Galo" – never with more pride than in 2013 when the

ABOVE RIGHT: The fox (raposa) mascot of Cruzeiro was devised in the 1930s by a local cartoonist. Later he said he had taken his inspiration from businessman Mario Grossa, who was then the club's president, and who was "as sharp, quick and intelligent as a fox". But it was another 30 years before the club's fans had an anthem ("Hino ao Campeao") to complete the set.

RIGHT: The rivalry which splits the city of Belo Horizonte is deadly serious between Cruzeiro and Atletico Mineiro. Here the cockerel (galo) mascot of Atletico taunts rival fans before the derby in October 2009. Cruzeiro, who claim to have the larger fan base in both city and region, were state champions that year with Atletico finishing runners-up.

inspiration of veteran Ronaldinho fired them to their first victory in the Copa Libertadores at the expense of Paraguay's Olimpia.

The Atletico–Cruzeiro rivalry is a perfect example of the derby intensity which is mimicked, state by state, city by city, throughout Brazil. Enormous banners representing both clubs blanket down across the fans in the stadia before a game, and the colours and vibrancy among the supporters multiply, many times over, the images which television viewers have enjoyed seeing on their screens at every World Cup when the cameras pan around the stands and across the *torcida*. Those Brazilian fans also pride themselves, it should be noted, in counting the prettiest girls – and a high number of them – among the fan base on match day.

Football support is not "merely" tribal, it is social, sociable, integrationist and represents a level of togetherness which speaks passionate volumes about the nation itself.

Down in the south of Brazil is Porto Alegre, where a similar rivalry fuels the passion between supporters of Gremio and Internacional. Many German immigrants to Brazil in the early twentieth century settled in the south because they found the climate more agreeable. Hence German and English pioneers founded Gremio in 1903. The following March they played their first competitive match, against the similarly German-inspired Fussball Porto Alegre and won 1–0. The trophy they won sits in the club museum to this day.

A Gaucho state league was set up in 1910 and Gremio's rivalry with Internacional (founded 1909) was launched with an overwhelming 10–0 victory in the first Gre–Nal derby. Legend has it that Gremio's underworked goalkeeper sat in the crowd, nattering with friends and family, as his team-mates put Inter to the sword at the other end of the pitch. Years later the tables were turned with Internacional's all-conquering team of the 1940s known as the "Rolo Compressor" (Steamroller).

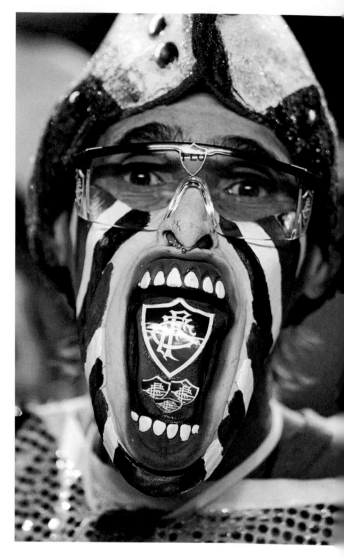

❝ Against Fluminense the noise was always unbelievable. We could see our coach shouting orders. We never bothered to say we couldn't hear him. ❞

Zico, Flamengo superstar on playing in Maracana in the 1970s and 1980s

In Parana, also down south, Coritiba and Atletico Paranaense, from Curitiba, may be the least well known abroad of the major clubs but their own domestic power is set out in around 60 state titles. Coritiba also claim a world record of 24 successive competitive victories. Parana is another state which attracted German immigrants and thus the local football clubs developed out of German-model gymnastics societies.

Recife, up on the north-eastern coast of Brazil, lays its own claim as one of the founding forces of the nation's football courtesy of Guilherme de Aquino Fonseca. He brought home one of the city's first footballs from his studies at Cambridge University and put it to good use by creating his own club: Sport Club do Recife. In truth, traditional local

OPPOSITE: A fan of Fluminense takes his passion for both the club and support to a face-painting and face-masking extreme. The occasion was a Rio de Janeiro derby against Flamengo in the Copa Sudamericana, South American equivalent of the Europa League. In 1963 the world's record club attendance of 195,000 was recorded at a Flu–Fla derby in the Maracana.

BELOW: The enduring rivalry in Porto Alegre, in the south of Brazil, is between Internacional and Gremio. Inter are one of only three clubs to have competed in all the national championships since 1971, though they have won it only three times. The first-ever goal in the competition was scored by Argentinian Hector Scott, playing for Gremio.

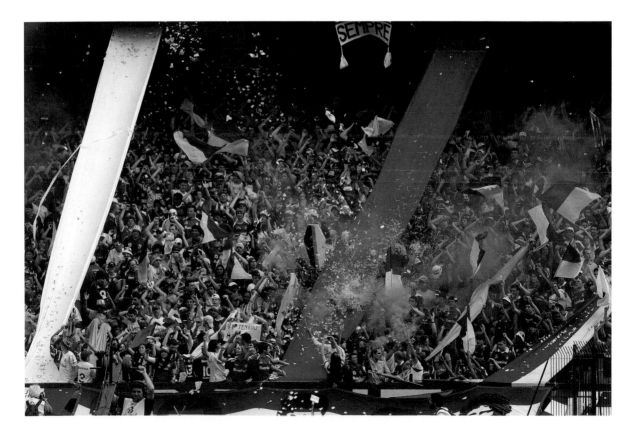

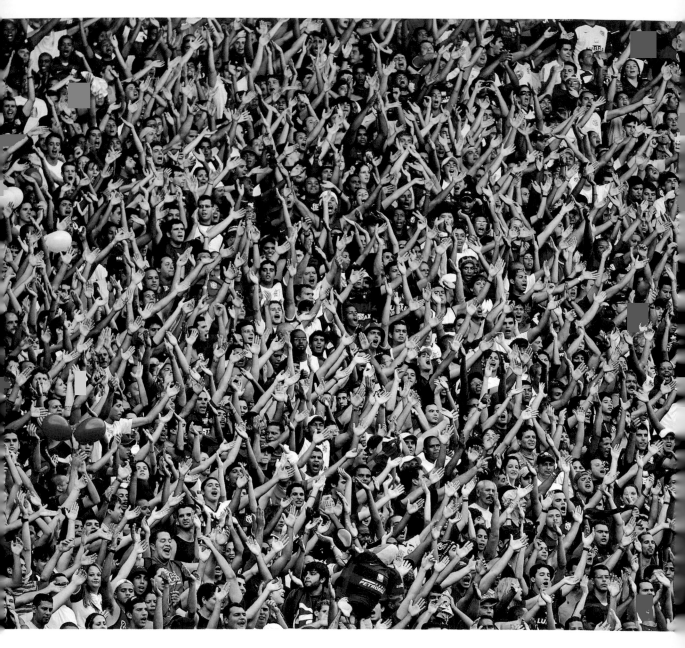

ABOVE: Flamengo supporters have plenty about which to cheer. The "Rubro-Negro" (red and blacks) have won every international and national prize and claim, across the country, the largest domestic fan base in the world. The date of the club's foundation, November 17, has been declared officially as "Flamengo Day" by the city of Rio de Janeiro.

OPPOSITE: Flamengo's Junior is chased down by Liverpool's Sammy Lee in the 1981 World Club Cup Final in Tokyo's National Olympic Stadium. Flamengo won 3–0 to the delight of the majority of the Brazilian football-loving Japanese fans. Flamengo striker Zico later returned to Japan not only as a player, then coach, but also subsequently as national team manager.

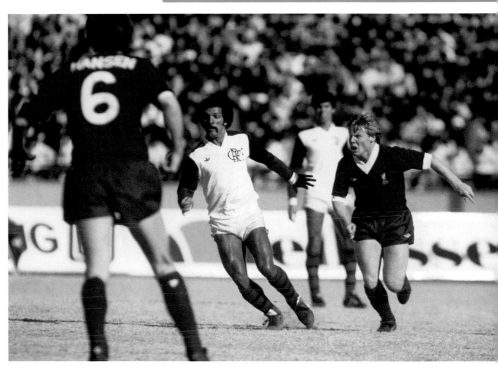

rivals Nautico had been founded two years earlier and it seems Fonseca was "merely" among a number of disaffected members who, literally, took their ball away. Even so he is honoured with eternal gratitude as having been the local "Oscar Cox" or "Charles Miller".

Cox and Miller were the two homecoming students credited with introducing organized football to Sao Paulo and Rio. In the latter, "Campeonato Carioca" (still the name of the city's league) was launched in 1906 with its most enduring rivals, Cox's Fluminense and Flamengo, having evolved out of rowing clubs. Flamengo were founded in 1895, turned to football at the behest of "Flu" rebels in 1911 and claim an unverifiable world record fan base of 39 million. Certainly they can boast a cast list of great players down the years from Leonidas and Domingos da Guia in the 1930s and on via Zico and Junior in the 1970s and 1980s. A multi-sport club, the roll of honour also features 19 Olympic medallists.

Zico inspired a memorable World Club Cup win over Liverpool in 1981 and, in terms of titles, the "Rubro-Negro" (red-and-blacks) edge Fluminense by 32–31. In 1963 the Fla–Flu derby – nicknamed thus by the legendary journalist Mario Filho – drew a world record attendance for a club game of 177,656 to Maracana.

Fluminense do, however, lay claim to having won a world title almost 40 years before Flamengo. That was in 1952 when Filho, after whom Maracana is named officially, proposed the promotion of Rio as the capital of world football.

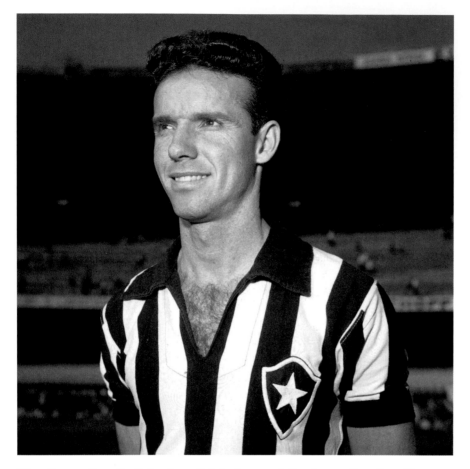

The city was then the federal capital, had a population larger then than Sao Paulo, boasted the world's biggest stadium and, despite the Maracanazo of 1950, had an appetite for more international competition.

Filho "sold" the idea to Rio mayor Mendes de Morais, to the Brazilian sports confederation (CBD) and to FIFA directors Ottorino Barassi of Italy and England's Stanley Rous. The world federation's veteran French president Jules Rimet approved the concept then retreated for fear that FIFA would have to pick up the bill.

In the event the CBD organized it with two mini-leagues in Rio and Sao Paulo in the summers of both 1951 and 1952. Palmeiras won the first edition and Fluminense the second, beating Corinthians 4–2 over two legs in the final. Both games were staged in Maracana and Flu claimed overall victory as the only club unbeaten in the two years. Six years later Flu playmaker Didi and Corinthians' goalkeeper Gilmar would line up together when Brazil finally won a World Cup "for real" in Sweden.

In the next decade – trophy or not – all four of Rio's club teams ranked among the finest in the world, after Pele's Santos. Botafogo boasted World Cup winners

"*I wish this Copa Rio competition every possible success out of my sympathy and admiration for everything Brazilian football represents.*" *Jules Rimet, former president of FIFA, in 1951*

BELOW: Didi was Brazil's creative "brains" in the 1950s and early 1960s. He was the first player to score a goal in Maracana and the scorer of the "falling leaf" free-kick goal which edged Brazil to victory over Peru in a decisive 1958 World Cup qualifier. Later he managed Peru at the 1970 World Cup when they lost in the quarter-finals to Brazil.

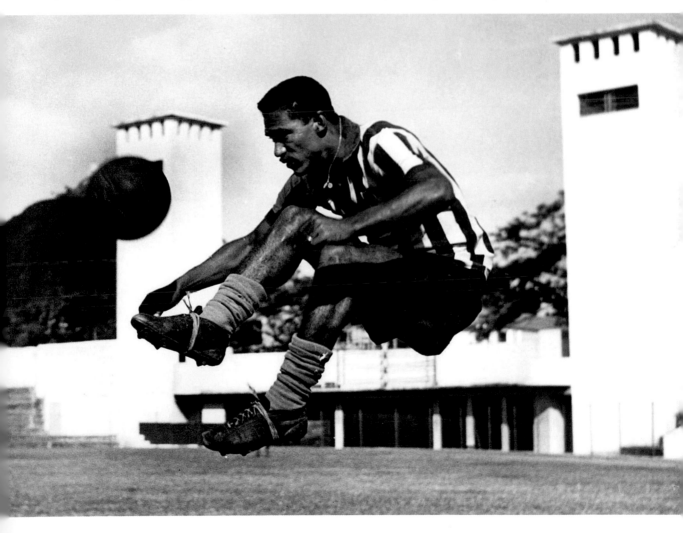

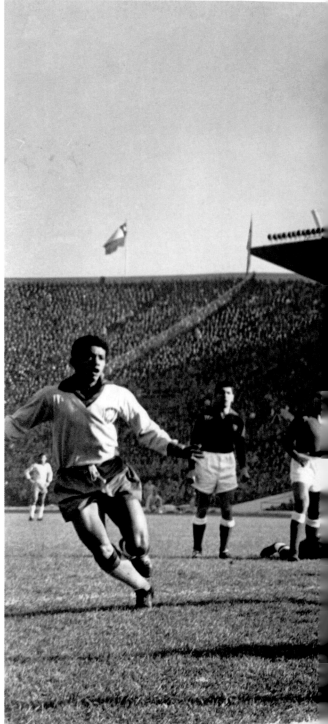

ABOVE: Nilton Santos, not related to team-mate and right-back Djalma Santos, was far more than "just" Brazil's left-back in their first World Cup triumphs. He was the senior professional and an astute judge of players. Coaches listened to his opinions and acted on them. Unusually, Santos played for only one club throughout his career: Botafogo.

RIGHT: Amarildo (left) celebrates another Brazilian goal on the way to their 4–2 win over hosts Chile in the 1962 World Cup semi-final in Santiago. Early injury to Pele had handed Amarildo a surprise chance of World Cup stardom. A club-based understanding with Botafogo team-mates was a key factor in his scoring three important goals.

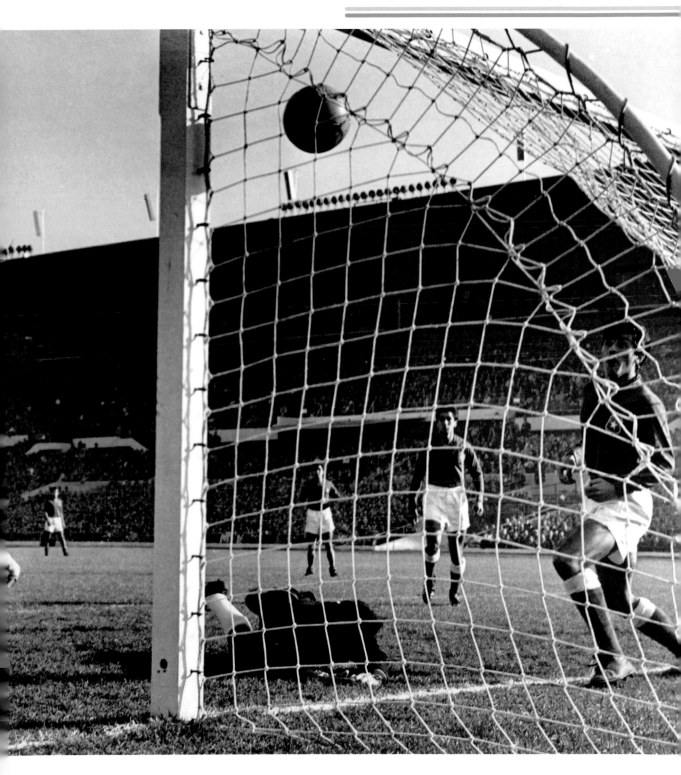

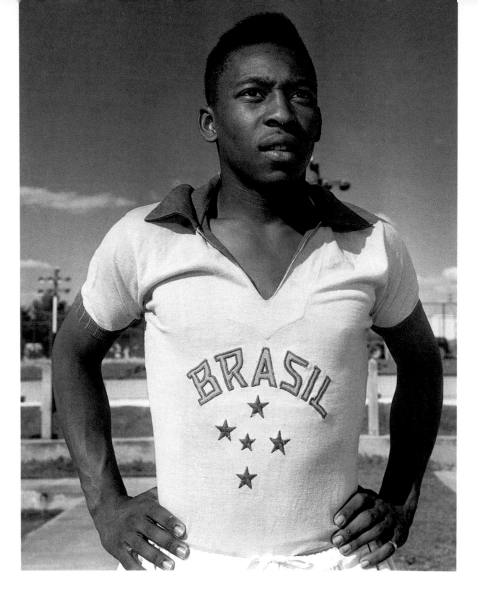

RIGHT: Pele was 16 years nine months when he made his debut for Brazil against Argentina in 1957 and became the then youngest player to score a goal in an international. His last game for the "Selecao" was against Yugoslavia in the Maracana in 1971. Brazil lost only 11 of his 92 full internationals in which he scored 77 goals.

OPPOSITE: On top of the world – again. Captain Zito grasps one of the trophies on offer after Santos beat Benfica to win the 1962 World Club Cup. He and team-mates such as goalkeeper Gilmar, centre-back Mauro, midfielder Mengalvio and forwards Coutinho, Pele and Pepe had also been members of Brazil's World Cup-winning squad three months earlier.

Nilton Santos, Garrincha, Didi, Amarildo and Mario Zagallo; Vasco da Gama won the prestigious Paris tournament in 1957 with Bellini and Orlando at the heart of defence and later added Vava in attack.

Down in the Paulista league Santos, before Pele came along, were always outsiders. Indeed, until the advent of "O Rei" they were merely the "port club" and their modest little Villa Belmiro was more than big enough. Once Pele exploded on to the scene everything changed; Santos even "exported" some of their high-profile international fixtures to Rio in front of 100,000-plus crowds at Maracana.

Left, temporarily, in the shadows were Corinthians and Sao Paulo, though they would reclaim their pre-eminence early in the twenty-first century when both won the newly reorganized FIFA Club World Cup.

Palmeiras complete the Paulista power game. Like Cruzeiro, their Italian-rooted club had to change the club name from Palestra Italia in 1942.

Coincidentally one of their 1950s favourites, the centre-forward known as Mazzola, became an even greater hero in due course in Italy under his real name of Jose Altafini, with Milan, Napoli and Juventus.

Altafini counts among more than a dozen Brazilians who also gained international honours with Italy in the days when qualification rules were virtually non-existent. One of the last was Angelo Benedetto Sormani, who sought an opening in the Italian game after being held back at Santos by the attacking pre-eminence of "goal twins" Pele and Coutinho.

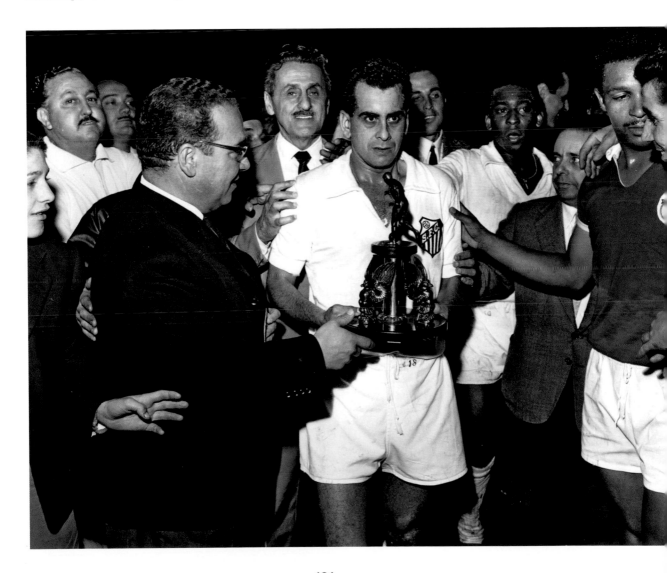

No sooner had Sormani left, barely noticed, than Santos became the first Brazilian club to win the Copa Libertadores, the South American club cup.

The competition had been launched in 1960 to produce a world title challenger to the winners of the Champions Cup, which had created an international sensation beyond Europe. Bahia from Salvador were Brazil's first entrant but fell in the first round on aggregate to Argentina's San Lorenzo. Palmeiras reached the final in 1961 but lost to Uruguay's Penarol.

Third time lucky, Santos brought home the trophy in 1962 before marching on to lay waste, in masterful fashion, to Benfica of Portugal in the World Club Cup. "Peixe" (The Fish) repeated the double trick 12 months later, then jetted off around the world for much of the next seven years. Titles and fans at home were forgotten as Santos became dollar millionaires by cashing in on match fees generated partly by their world title status but, even more important, by the crowd-magnetizing aura of Pele.

Meanwhile a falling-out with the South American confederation saw Brazil's clubs boycott the Libertadores to Argentina's benefit. Not until Cruzeiro beat Argentina's River Plate in 1976 did Brazil reclaim title pride. A further eight clubs have emulated them, but Brazil's total of 17 Copa victories still lags behind Argentina's 22.

Similarly Brazil's national team, with a mere eight Copa America celebrations, trail not only Argentina (14) but Uruguay (15). That, however, says more about the erratic organization of the competition down the years than the comparative talent of the nations. More irritating for Brazilian fans is the knowledge that both Argentina and Uruguay have also enjoyed Olympic glory.

This spectre, at least, can be set to rest on home ground in Rio de Janeiro in 2016.

LEFT: The 2014 World Cup hopes and dreams of all Brazil will rest most firmly on the shoulders of Neymar da Silva Santos Junior. By the time he was 20 the Santos striker had been acclaimed twice over as South American Footballer of the Year. Neymar was 18 when he scored on his Brazil debut against the United States and, at 21, cost Spanish giants Barcelona £48 million.

"Everything I won, every goal I scored, increased the weight of pressure on my shoulders. But so much the better. I'd turn it into energy and motivation so I could do even better." *Ronaldo, 2002 World Cup winner*

ABOVE: Centre-forward Ronaldo Luis Nazario de Lima was picked for Brazil's 1994 World Cup squad in the United States "for experience", so never played a single minute, watching Romario and Co win the crown. The experience paid off: Ronaldo starred in 1998, 2002 and 2006 to become the highest aggregate scorer in the competition's history with 15 goals.

OPPOSITE: The career of Ronaldinho (right) appeared to be fading fast when he returned to Brazil from Milan in 2011. After a year with Flamengo he regained all his love of the game with Atletico Mineiro. In 2013 he led "Galo" to victory (pictured) against Olimpia of Paraguay in the finals of the Copa Libertadores, South American equivalent of the Champions League.

Chapter 7
THE STREET AND BEACH

Every tourist visiting Rio de Janeiro, usually sooner rather than later, grabs time out to take a trip up the long and winding road which leads to Cristo Redentor – Christ the Redeemer.

The statue of Christ the Redeemer with his arms thrown open wide to embrace all of the city, its hills and magical coastline, was erected in the late 1920s. On a sunny day tourists flock all around it, staring up at the stylized features; and they pose for pictures with their arms thrown wide in mimicry while condors rise and glide on the air currents above the scene.

On the way up, and on the way down, the same visitors may also gain a less pleasing view by glancing across through the trees at the *favelas* which crawl up the neighbouring hillsides.

The steep perches are easily explained to the curious: no one else would build there and it saves on complex drainage. When the rains come, the waters flood down the roads, alleys and pathways and, not unusually, take these perilously poised homes down with them.

The favelas provide shelter for the poor, havens for drug gangs and a never-ending challenge for law enforcement. By the time the Olympic movement flies in to Rio de Janeiro for the 2016 Summer Games the favelas which have scarred the city are supposed to be history if a community police project is successful.

RIGHT: The irresistible beaches of Rio de Janeiro played a key role in the evolution of Brazilian football. The original, highly popular rowing regattas were staged down the coast in the late nineteenth century. Within a few years sailing clubs such as Flamengo, Fluminense and Vasco da Gama had expanded to embrace the new, novelty game of football.

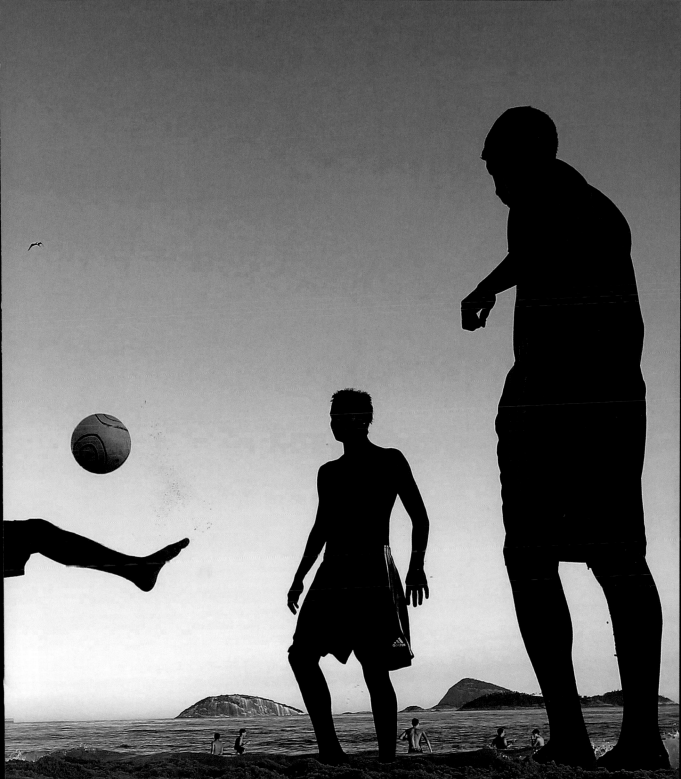

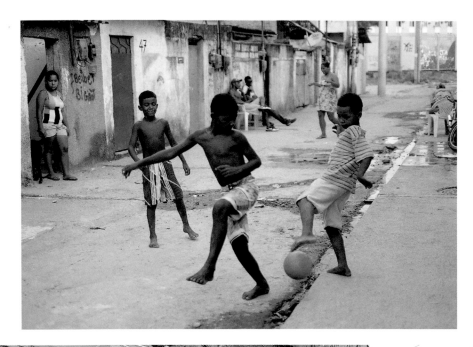

LEFT AND BELOW:
Children at play ... in the Cidade de Deus, west of Rio de Janeiro. The "City of God" had been constructed in the 1960s as a new home for residents from more than 20 favelas. Soon it became a haven for drugs gangs, but the attention brought to it by a film about local life led to the implementation in 2009 of one of the first police pacification projects.

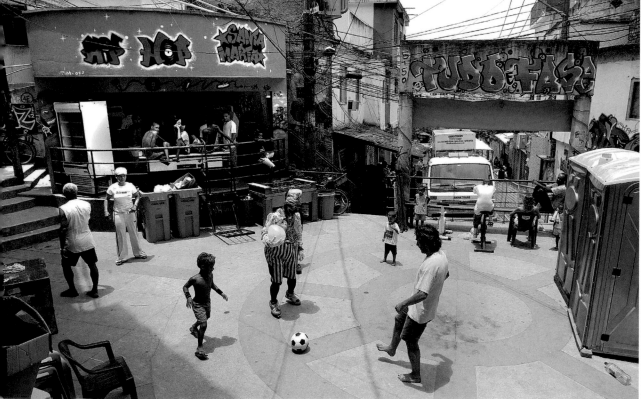

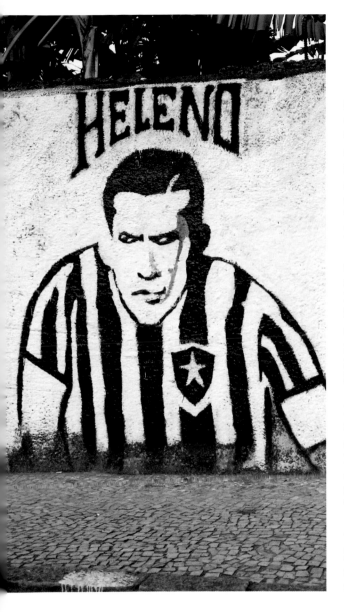

Renewed focus on the favelas was generated in 2007 and then again in 2009 by the awards to Rio of not only the Olympics but also the 2014 World Cup. At the time Jorge Barbosa Pontes, initially appointed as international security relations manager for Rio 2016, described the challenge as one of creating a perception of safety for visitors through a community security force entitled the Unidade de Policia Pacificadora (UPP), or Pacifying Police Unit.

Visitors to the Confederations Cup in June 2013 saw little evidence of change as the football vied for media coverage alongside the street protests and, in Rio, the latest gun battle deaths from a police move into the Mare favelas out near the international airport. Hence life in the favelas continues to present a compelling reason why the few fortunate youngsters should capitalize on their sporting talent in search of escape.

Despite the romantic image, comparatively few have been successful. Many, throughout much of the twentieth century, ended their lives in as wretched a state as they had begun. The legendary Heleno de Freitas was such a talent. Even today he remains an iconic figure from the "lost" years of the 1940s: never offered the opportunity of World Cup glory because of the accident of timing of his birth.

One of eight children, Heleno was brought to Rio by his widowed mother when he was only 11 in 1931. He was one of the original rags to riches heroes. He and his brothers studied by day and played football in the streets and on the beaches during the evenings.

ABOVE: Not only are the new heroes and celebrities remembered in graffiti. Heleno de Freitas was Brazil's playboy superstar back in the 1940s. He was spotted by Botafogo juggling oranges on the local beach. Heleno liked to play to the crowd, both on the pitch and off it, in clubs and casinos. Sadly, living the dream drove him to dementia and a debt-ridden death at 39.

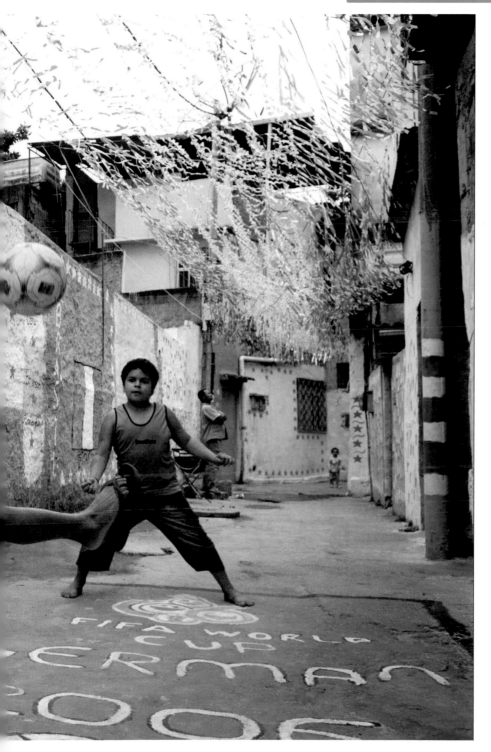

LEFT: An everyday scene in Vila Cruzeiro in Rio de Janeiro, one of the most notorious favelas. Vila Cruzeiro was childhood home to Adriano, top scorer at the 2005 Confederations Cup. The legacy of his childhood returned to haunt Adriano as his career tumbled through alcoholism, suspensions, injuries and rows with referees, directors, coaches and journalists.

> **"Brazil is the world's fifth power. I just wish we had less poverty and more social equality. The government and people need to take advantage of the World Cup to make all this happen."** *Pele*

Such was his passion for the game that, as he grew older, he played simultaneously as an amateur with Botafogo and as a professional with Fluminense. Later he turned professional with Botafogo. He was worshipped by fans as the most classic of centre-forwards, scoring goals and making them with equal grace and facility.

But, somehow, he and Botafogo missed out on all the prizes. As the trophyless seasons ran frustratingly on, so Heleno's behaviour grew increasingly erratic: his larger-than-life football and playboy personas were, literally, the death of him. He clashed with team-mates, coaches, referees and directors both in Brazil and then during short spells in Argentina and Colombia.

Back home in Brazil, wracked by syphilis diagnosed and treated far too late, Heleno died a lonely death in the closed ward of a hospital. At 39 the star who once drove a Cadillac and splashed his cash in all the most fashionable nightclubs on Copacabana was as poor as when he had first kicked a football down the hill.

Happily later heroes – and two in particular – have proved that this was not the inevitable fate for football children of the favelas. One was Romario, the other Ronaldo.

ABOVE LEFT AND RIGHT: Youngsters play football on makeshift sand and concrete pitches in the favelas of Sao Paulo and Rio. The rough dirt pitches and the streets of Brazil's towns and cities have proved both an informal academy for ambitious youngsters and a profitable scouting ground for clubs big and small.

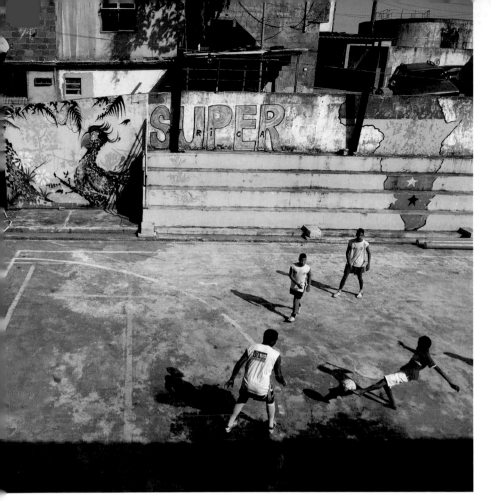

PREVIOUS PAGE:
In March 2009 the Brazilian
parliament approved a
law designating street
art and graffiti as legal if
undertaken with the consent
of building owners. This
example featured stars of
Brazil's 2010 World Cup
squad in South Africa
standing together in the
bondinho, the cable car
which takes tourists to the
peak of Sugarloaf Mountain.

RIGHT: Ronaldo, then
playing his club football with
Internazionale, returned
regularly to Brazil between
the 1998 and 2002 World
Cups for treatment and
convalescence after career-
threatening knee injuries.
He found it hard to keep
away from Copacabana,
and is seen here in a
promotional demonstration
of "futvolley", a blend of
football and volleyball.

The latter, the 15-goal leading marksman in the history of the World Cup finals, started life in a one-bedroom shanty in such a hillside favela on the fringes of the middle-class suburb of Bento Ribeiro. His parents Sonia and Nelio struggled to make ends meet on the equivalent of $30 a week.

Nelio always said it took them four days to raise the minimal registration fee demanded after Ronaldo's arrival in the world. Hence he has two birthdays: September 18 (when he was born) and September 22 (the registered date).

Ronaldo was fortunate. When he was four his father gave him a plastic football for Christmas. Most kids from the wrong side of the tracks did not have even that luxury. They had to make do with a ball of rags (like Pele) or tin cans, or make friends with a kid who did have something resembling the real thing.

Soon he was spending five or six hours a day playing on waste ground with friends and relatives. Mother Sonia had to walk him to school and see him through the gates to ensure he was not tempted away by a *pelada*, a street game, along the way.

Weekends were spent playing football on the beach at Copacabana, and from there it was a step up to organized football with any one of hundreds of local youth clubs. Later he began playing organized youth football with Sao Cristovao, and the rest is World Cup history. Now Ronaldo is a senior member of the 2014 World Cup organizing committee, the man left to help restore confidence after the sudden, scandal-ridden flight from Brazil of former CBF president Ricardo Teixeira.

Romario, Ronaldo's predecessor with Holland's PSV Eindhoven and Spain's Barcelona, graduated similarly from rags to riches. Born and brought up in the Rio favela of Jacarezinho, Romario was taken to the beach every Sunday by his father, Edevair. In the morning Edevair taught him to swim, in the afternoon they played football. Soon Edevair recognized that his son had real talent. So he created his own beach team, Estrelinha, around the boy.

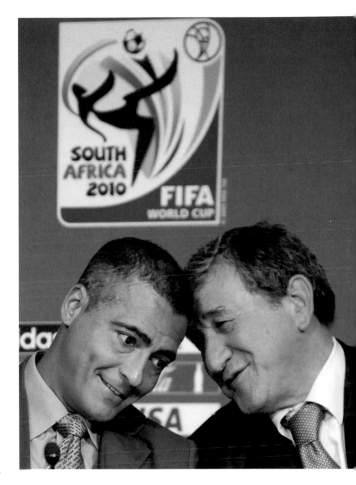

ABOVE: Together again. In 1994 Romario (left) was top-scoring striker for coach Carlos Alberto Parreira in Brazil's World Cup-winning campaign in the US. By 2010 Romario had embarked on a political career which would see him elected to Congress, while Parreira had become manager of hosts South Africa at the World Cup finals.

In due course it was time for the father to let go, and Romario did not need further encouragement to make his way even in such a competitive teenage football world. Soon he was starring at Vasco da Gama alongside his hero, Roberto Dinamite. But the memory of the favela drove him as far and fast as possible on beyond football and to an equally prominent political career in Congress.

Never once, during his rise, has Romario forgotten his childhood and a focus bordering on obsession. As he once told an interviewer, looking back on his early days: "When I wasn't playing football I was playing football."

Of course Brazilian love of sport stretches beyond football. Motor racing is another competitive sphere to have put Brazil on the world map. Emerson Fittipaldi from Sao Paulo was the first Brazilian to win the Formula One crown in 1972, a success he repeated in 1974. Nelson Piquet went one better with three world titles, as did the charismatic Ayrton Senna before his death at Imola in 1994.

Boxer Eder Jofre was a world champion at bantamweight in the 1960s, then featherweight in the 1970s; in tennis Gustavo Kuerten was three times French Open champion between 1997 and 2001; and showjumper Rodrigo Pessao was a world championship and World Cup winner in the 1990s.

Brazil entered the Olympic Games in 1920, and currently has a total of 108 medals (23 gold, 30 silver, 55 bronze) and a ranking of 32nd overall, but expects to celebrate a record haul when Rio hosts the summer spectacular in 2016.

The first Brazilian to win gold was marksman Guilherme Paraense on Brazil's Games debut in Antwerp. He had needed more than a little help from the American rivals whom he beat. A lieutenant-colonel in the army, Paraense arrived in Belgium to find that his pistol and ammunition had been stolen during the month-long journey by sea and rail. The US delegation loaned him some Colt pistols and ammunition and he won gold in the rapid-fire competition by two points from American Raymond Bracken.

Other Olympic champions have included sailor Robert Scheidt (Atlanta 1996 and Athens 2004), long-jumper Adhemar da Silva (Helsinki 1952 and Melbourne 1956) and swimmer Cesar Cielo (Beijing 2008). Double amputee Alan Oliveira shattered the aura of invincibility surrounding South Africa's Oscar Pistorius when he won the T43 100 metres in 10.57 seconds during the Paralympics at London 2012.

Nor have all the headlines been commanded by Brazil's men. Maria Lenk, who learned to float in the Tiete in Sao Paulo in the days before municipal

> **"All this talk about football on the beach: It wasn't as carefree as people like to think. But it still says something about how we Brazilians come to football. It's not a job, it's a joy."**
>
> Mario Zagallo, World Cup winning coach in 1970

swimming pools, was the first South American woman to compete in the Olympics. She reached the 200m breaststroke semi-finals both in Los Angeles in 1932 and in Berlin in 1936. She had been gold medal favourite heading towards the doomed 1940 Games scheduled for Tokyo.

Jacqueline Silva was a winner when beach volleyball made its Games debut in Atlanta in 1996; Maurren Maggi was Olympic long-jump champion in 2008; Hortencia (de Fatima Marcari) and Magic Paula (Maria Paula Gonçalves da Silva) starred in Brazil's silver-winning basketball team in 1996, and Terezinha Gilhermina won Paralympic gold in the 200 metres in Beijing.

In the late 1950s and 1960s Maria Bueno graced the international tennis circuit and was three times a winner at Wimbledon, twice in the singles and once in women's doubles.

BELOW: For real, the idealistic image of Brazilian football as far as the rest of the world is concerned: teenagers, apparently without a care in the world, practise a range of tricks and ball-playing talents for their own entertainment as the sun goes down beyond world-famous Copacabana beach ... on the eve of the 2013 Confederations Cup.

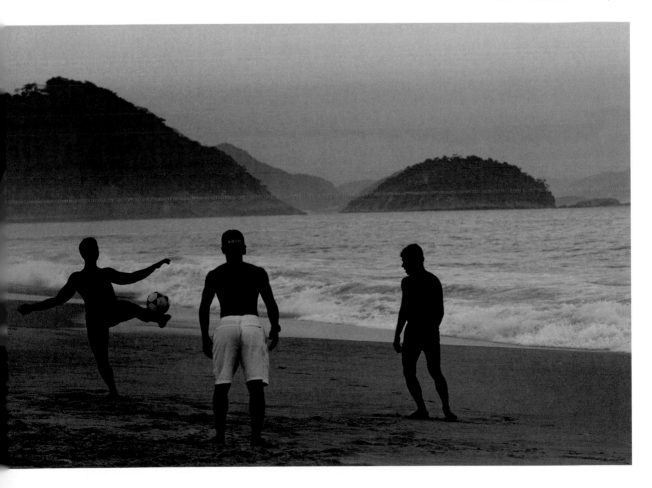

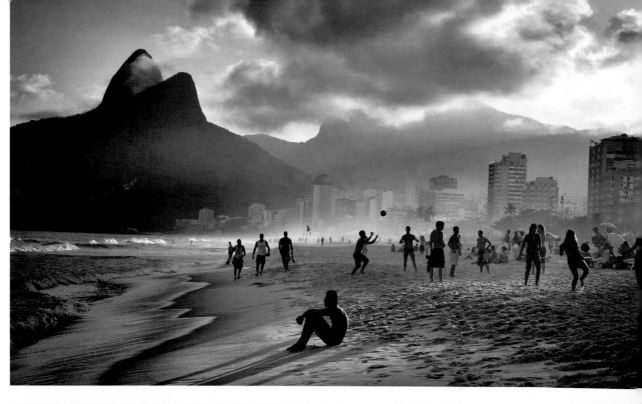

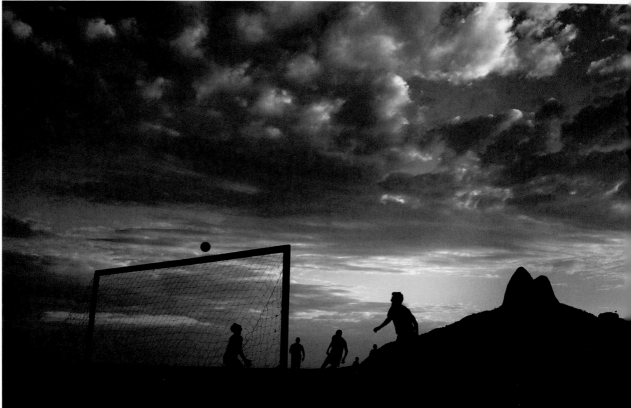

But while all ranked as popular national heroes and heroines, most came from privileged backgrounds. Motor racing and tennis and showjumping were elite sports taking place as if in another world. The equipment or specialized facilities or sheer cost – or all three put together – were far beyond the reach of the vast majority of sports-mad youngsters.

Not so football. Any and every kid could dream of following the example of a Romario or Ronaldo and progressing from street to beach to fame and fortune. Indeed, the connection of ambition and simple opportunity has been underscored by the development of beach football from informality to international championship.

Inevitably the tradition and ongoing popularity of football on the beaches led to commercialization of the concept. Initially a myriad of small promotional companies sought to gain a toehold, but the market proved as insecure as the sand on which the game was played.

Back then beach football was based on the usual 11-a-side game, but the teams had gradually shrunk in half by the time the first professional championship was organized in Miami Beach in 1993 with sides from Brazil, the United States, Italy and Argentina.

A year later, on Copacabana, the competition was televised for the first time. This prompted the creation of the Pro Beach Soccer Tour which organized 60 games in two years across South America, Europe, Asia and the United States.

Accelerating popularity of the commercial, competitive version led to the organizers, Beach Soccer Worldwide, roping in old World Cup heroes. The joint top scorers at the first Beach Soccer World Cup in 1995 were former World Cup stars in Brazil's Zico and Italy's Alessandro Altobelli. Each scored 12 goals and Brazil, appropriately, thrashed the United States 8–1 in the final.

Indeed, Zico and old World Cup team-mates Junior and Eder had more title success in the beach game than in the turf version. Zico and Junior were both winners in 1995 and 1996, while Junior was on the winning side again in 1997, 1998, 1999 and 2000.

Leovegildo Lins da Gama Junior was another, perfect example of a player who learned his technique on the beach and took his technical ability plus his pace and energy to the highest levels of the club game with Flamengo and to the World Cup finals with Brazil. He was equally adept with both right and left feet, though he played largely as a left-back, then a left-side midfielder.

Scouts from the Rio clubs patrol the beaches, and the youngsters are all ambitious to catch the eye with their tricks and skill. Junior was one of the fortunate ones who made it up into the professional game but always insisted he never lost the love of the game which he had developed on the sands. His coaches down the years were driven to despair by the risks he took with his fitness in sneaking back to the beaches to join in for the sheer fun of it.

With 865 games Junior made more appearances for Flamengo than any other player in two stints which bookended a spell in Italy with Torino and Pescara. At 35, in 1989, he was ready to retire when his son, who had never seen him play, persuaded him to extend his career back home with Flamengo.

OPPOSITE TOP: Sand, sea and soccer. Brazilians and visitors of all ages enjoy their dreams of superstardom on Ipanema beach in the shadow of both the early-evening clouds and the Sugarloaf. Ipanema's worldwide fame was earned initially not so much through football as through the bossa nova rhythms after two local men came up with "The Girl from Ipanema".

OPPOSITE BOTTOM: From one extreme to the other. Men play a makeshift game of football on Ipanema to while away the time before, the next day, they either watch Brazil confront world champions Spain in the final of the 2013 Confederations Cup ... or join the street protests against government expenditure on World Cup preparations.

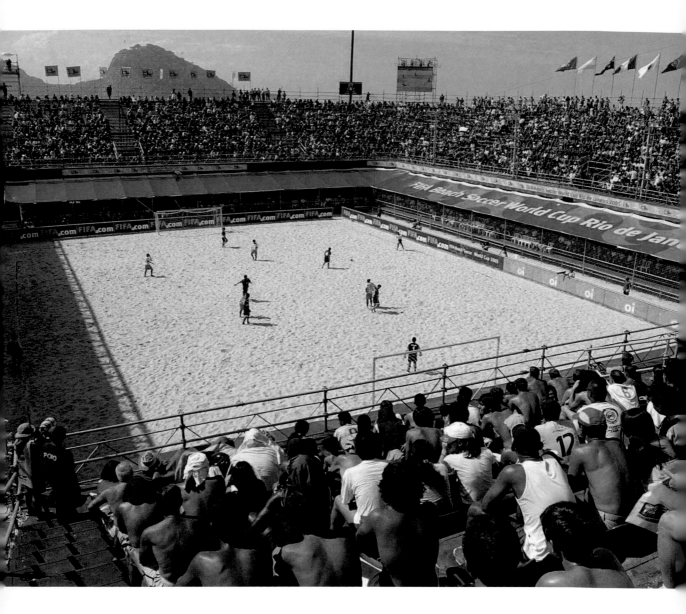

ABOVE: Rio de Janeiro established itself immediately, in
the 1990s, as the capital of the fast-expanding international
beach soccer empire. Copacabana hosted the first official
finals in 1995. Here Brazil are beating Thailand 9–2 in a
temporary stadium on the Copacabana sands on their way
to a third-place finish in 2005.

> **"Every time we play it becomes more demanding because of the way beach football has grown up."**
>
> *Junior Negao, Brazil's coach after their third-place finish at the 2013 Beach World Cup*

They won the Brazilian cup and the Carioca championship twice before he became coach, but he hated the job and stepped down in 1994 ... to pick up a new challenge back in the beach game and hence returned to his roots. For many observers of the circuit, Junior is the greatest player ever to grace the sand. Five times he won the Beach World Cup and eight times the South American title; four times he was voted best player and four times he was the leading scorer.

Not surprisingly the statistics demonstrate Brazil as the dominant force. This remained the case even as beach football produced its own game-specific stars and there was no longer room for many of the old professionals whose "orthodox" skills were not particular enough to adjust to the demands of a game where controlling the ball out of the air rather than on the sand/ground is crucial.

Indeed, so dominant were Brazil that the first 13 annual world championships were staged there, with 10 of them being played on Copacabana. The first finals to "escape" from Brazil were staged in Marseilles, France, in 2008, when Italy lined up one Diego Maradona, Italian-born son of Argentina's icon. The young Maradona scored Italy's third in a 5–3 defeat by Brazil in the final,

The French had earned the right to play hosts by dint of being Europe's most outstanding challengers. Three times they had been runners-up to Brazil before finally winning in 2005, the first finals played under the official FIFA banner.

Coincidentally their winning coach was Eric Cantona – footballer, actor and wannabe poet and philosopher. The former Manchester United star allowed himself only limited playing time and ended the tournament with one solitary goal of his own in a 7–4 quarter-final victory over Spain. Brazil had to settle for third place despite the six-goal contribution of 1994 World Cup winner Romario, as competitive as ever at 39.

After 2009 the championship switched from being held annually to once every two years, with Ravenna in Italy playing host ahead of tournament awards to Tahiti in 2013 and Portugal for 2015. Of the 16 championships thus far, Brazil have won 13 and been losing finalists twice.

Today's *futebol* thus presents an even longer, more formal, more alluring route: from favela to pelada to beach to Maracana and on to European fame and fortune – then maybe an extended career on the beaches: a sweet, sandy circle of success.

Meanwhile, back in the favelas, change has been slow, for all the promises and goodwill and increasing focus ahead of the arrival of the great international sports circuses. In 2012 the commander of a UPP unit in the north zone of Rio was jailed for accepting $15,000-a-week "protection money" from a notorious drugs trafficker. Hence it's no surprise that youngsters remain impatient as ever to escape by the old, most traditional, sporting route: football.

It's a lottery. Only a fraction of the thousands of youngsters who attend trials with the Rio clubs make it all the way to the professional game, and little more than 10 per cent of the players who star in the Brazilian national championship emanate from the city of the beaches.

But the illusion is more important than the reality. Football has, does and will continue to offer the dream of escape ... and who would dare spoil one of the most romantic images of the football heaven awaiting the kids playing dreamily on the beaches beneath the outstretched arms of Cristo Redentor?

BELOW: Rio de Janeiro was the capital of Brazil until the creation of Brasilia in the 1960s. But it has remained the capital of Brazilian football. The football confederation is headquartered in Rio, which also boasted the world's largest stadium in 1950 when Maracana was built, then with a 200,000 capacity.

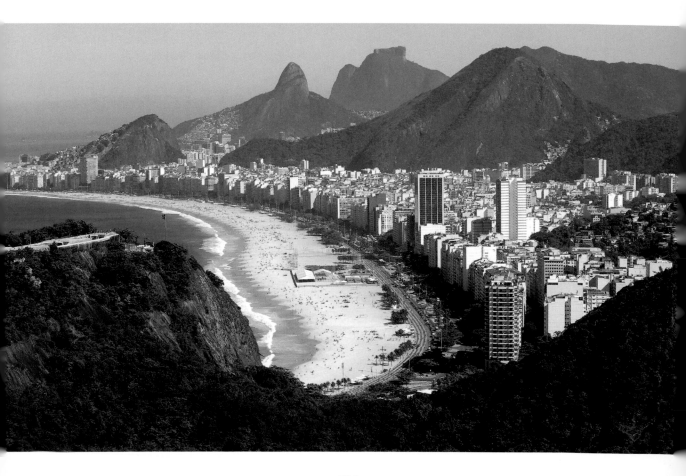

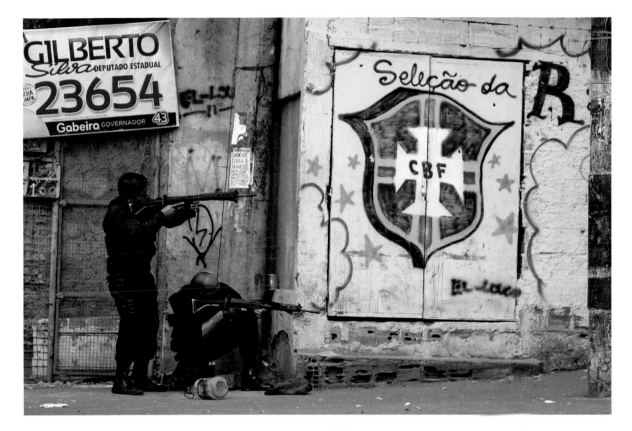

ABOVE: Armed security officers launch an operation against drug dealers in the Vila Cruzeiro favela in November 2010. The assault was a reaction to criminal gangs' violent response to a "pacification" project. By the end of the police action more than 40 people, mostly criminals, had been killed and 200 had been arrested.

NEXT PAGE: Football is a religion in Brazil. Hence the iconic statue of Cristo Redentor looks down, casting its benevolent arms wide, over the city of Rio de Janeiro, its beaches and bars, its mansions and favelas – and the Maracana stadium which hosted the World Cup Final in 1950 and will do so again on July 13, 2014.

> **"We have every confidence in our security services and their ability to keep our visitors safe during both the World Cup and then the Rio 2016 Games."** *Carlos Nuzman, president of the Brazilian Olympic Committee*

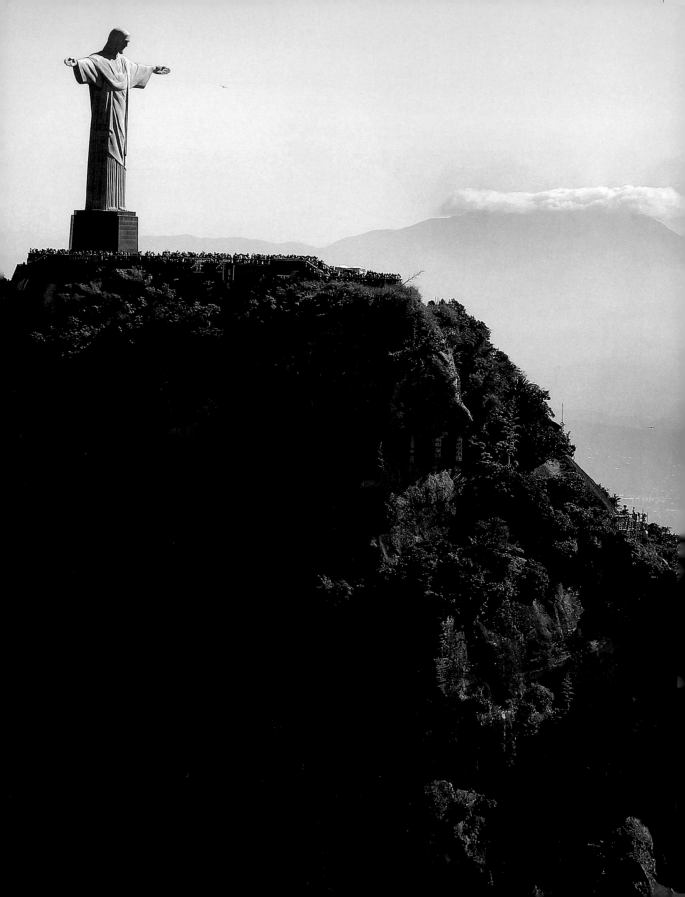

"Back home we have a saying: 'If the Pope is Argentinian then God is Brazilian'." *President Dilma Rousseff after her audience with newly-elected Pope Francis*

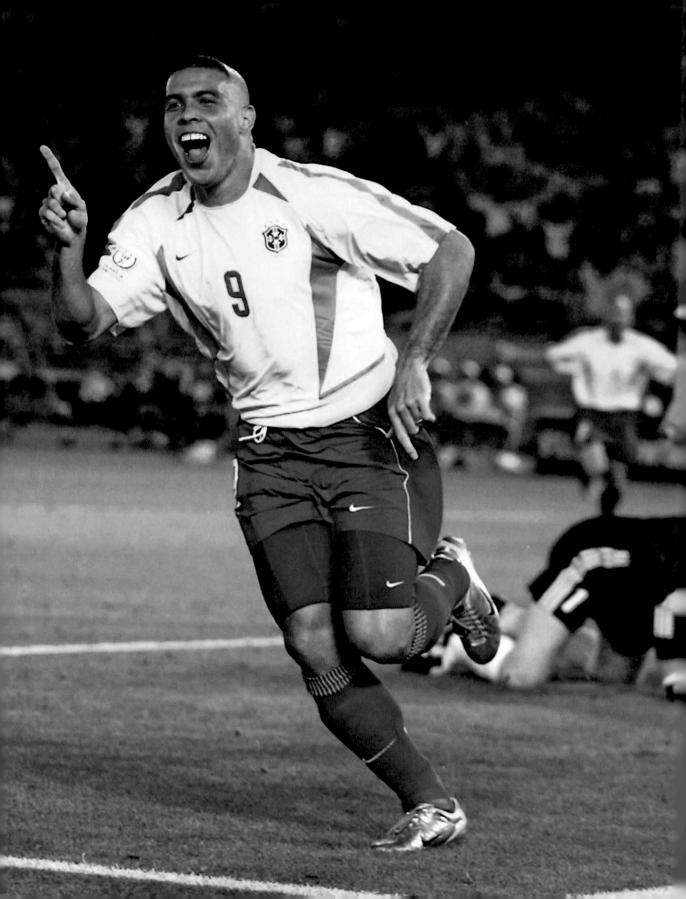

Chapter 8
THE WINNING HABIT

Repeated failures to regain the World Cup had become increasingly embarrassing because Brazil, in the 1970s and the 1980s, had lost it twice. Firstly, on the pitch, had come their dethroning in West Germany in 1974. Secondly, off the pitch, the golden Jules Rimet Trophy had been stolen from the CBF offices in Rio de Janeiro in 1983 and melted down.

The trophy, named after the French "creator" of the competition, had been awarded to Brazil in perpetuity after their third victory in Mexico in 1970. In the CBF offices it was displayed behind bullet-proof glass. However, the rear panel of the display cabinet was just wood, and it was no problem for the thieves to prise it off and steal the trophy.

The trophy had endured a mixed history. During the Second World War Ottorino Barassi, general secretary of the Italian federation, had hidden it under his bed and then in a chicken loft to keep it out of the hands of the Nazis. Later, in 1966, it was stolen from an exhibition in London ahead of the World Cup finals but fortunately discovered a week later under a hedge by a mongrel dog named Pickles.

But the trophy seems to have been jinxed. Pickles later came to a sad end, strangled on his own lead after it snagged a fallen tree branch as he chased a cat.

The end of the line for the Jules Rimet Cup itself came on December 19, 1983. Within hours of the theft the trophy had been melted down for its gold content. The CBF commissioned a replica for display at major events under close guard, as if it were the real deal.

LEFT: Ronaldo wheels away in delight after scoring Brazil's first goal in their victory over Germany in the 2002 World Cup Final. Brazil went on to win 2–0 to celebrate a record-extending fifth triumph. Ronaldo had just punished a slip by the German goalkeeper Oliver Kahn (right) who, ironically, would be awarded the golden ball as the official player of the tournament.

How coach Sebastiao Lazaroni, approaching the 1990 World Cup finals in Italy, must have wished winning teams could be ordered up so readily. Lazaroni was another modern coach who knew that Brazilian football had to be taken forward, but his own solution, a sort of 5–3–2 formation, was too much too soon for fans and media.

In many ways the Brazilian approach summed up the entire finals, in which too many fine players were constrained in too many safety-first formations. The fearful nature of the football was demonstrated by the fact that, in the knockout stage, four games were decided on penalties and four others needed extra time.

Brazil struggled past Sweden (2–1), Costa Rica (1–0) and Scotland (1–0) in the group, then played their best game in the second round only to be eliminated by Argentina. Diego Maradona, despite carrying a knee injury, laid on the single decisive goal for flyaway winger Claudio Caniggia.

This was Brazil's poorest World Cup since the group-round exit in England in 1966, and Lazaroni had to delay his return home until he could be confident that the emotions which prompted the burning of effigies of him in the streets of Brazil had also been extinguished.

BELOW: Captain Diego Maradona celebrates at the final whistle after Argentina's 1–0 victory in Turin left Brazil beaten and knocked out at the quarter-final stage of the 1990 World Cup. Maradona had created the decisive goal for Claudio Caniggia against a Brazilian team whose negative tactics were considered "unworthy" by a critical media and furious fans.

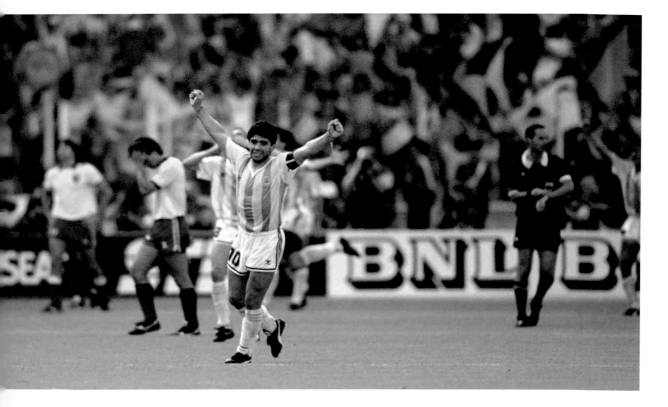

RIGHT: Carlos Alberto Parreira is a World Cup trend-setter in his own right. As well as guiding Brazil to victory in 1994 he also managed them to success in the 2004 Copa America and the 2005 Confederations Cup. On top of that, Parreira managed four other nations in the World Cup finals: Kuwait, United Arab Emirates, Saudi Arabia and South Africa.

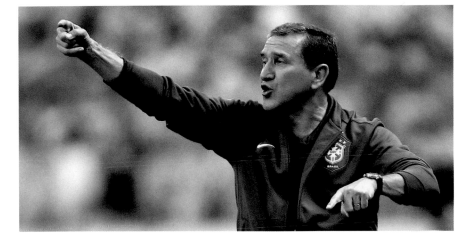

The players, accustomed to bringing back whatever luxuries they fancied from foreign trips, had their baggage impounded. Grumpy and envious customs workers, reflecting the mood of the nation, went through everything with rare zeal. The shocked players had to pay significant sums in import taxes.

Defeat in Italy was a baptism of fire for Ricardo Teixeira as president of the CBF. Teixeira, son-in-law of FIFA president Joao Havelange, had been elected in 1989. His reign, which lasted 23 years until March 2012, was marked by a never-ending saga of controversy over contracts and sponsorships but also by two World Cup triumphs.

The first was in the United States in 1994. Teixeira wasted no time, on the return from Italy, in replacing Lazaroni. Former World Cup midfielder Paulo Roberto Falcao had one brief, unconvincing year in the job before Teixeira lighted on Carlos Alberto Parreira.

> **Brazil are always favourites to win the World Cup. It's like a birthright. Of course, sometimes it doesn't work out.** *Carlos Alberto Parreira, 1994 World Cup winning coach*

The media was sceptical. Parreira had never been a top player but he was a man after the mould of the late Claudio Coutinho: both were expert fitness coaches, both were convinced of the need to mix and match technical and physical qualities, and both were internationalist in their outlook – hence avid readers of the London magazine *World Soccer*.

Parreira began his coaching career with "his" club, Fluminense, and then wandered the world. By the time he retired from mainstream coaching, Parreira had managed in nine countries and had led a record five different nations at six World Cup finals: Kuwait in 1982, United Arab Emirates in 1990, Brazil in 1994 and 2006, Saudi Arabia in 1998 and hosts South Africa in 2010.

Fortune always has a role to play in sport and Parreira's good luck was that his appointment to coach the national team coincided with a resurgence in the domestic club game. Sao Paulo won the Copa Libertadores in both 1992 and 1993 and lost the 1994 final only on penalties to Argentina's Velez Sarsfield.

Four Sao Paulo men figured in the squad Parreira took to the United States that year, but it was a sign of changing financial times that half the 22-man squad had to be recalled from foreign clubs. Key among them were hard-tackling Dunga from Stuttgart, captain Rai – younger brother of Socrates – and the matchless striker Romario. Parreira also took along, just for the experience, a 17-year-old striker named Ronaldo Nazario de Lima.

Parreira set up his team in pragmatic fashion: four at the back, two defensive midfielders and two wide men provided a secure foundation which freed Romario and strike partner Bebeto to cause havoc, however they chose, in attack.

Romario was a kid from the wrong side of the tracks. His self-centred approach to his football did not always find favour with his coaches but they all appreciated his brilliance, none more so than Sir Bobby Robson. The former England manager had a young Romario at his service at PSV Eindhoven in Holland and considered him one of the most naturally gifted players with whom he ever worked.

In due course Romario took his goals to Spanish football and Barcelona and would be five-goal top scorer and best player at the 1994 World Cup. Years later he would become a Congressman and prove as much of a handful for political opponents as ever he was for opposing defenders.

This was a unique World Cup. The idea of taking it to the US as a missionary effort had been controversial; for the first time since rejoining FIFA in 1946, no British team was present; Colombia's Andres Escobar was shot dead on his return home for the "crime" of having put through his own goal against the hosts; and Diego Maradona was kicked out in disgrace after failing a dope test.

OPPOSITE TOP: Midfielder Rai (right) shoots for goal in Sao Paulo's 2–1 victory over Barcelona in the 1992 World Club Cup Final in Tokyo. Ronald Koeman is too late to put in a tackle. Two years later Rai was a world champion again as a member of the Brazilian squad who won the World Cup in the United States. Rai was a younger brother of the 1980s hero Socrates.

OPPOSITE BOTTOM: Romario's career took him from depression to delirium within less than two months in the summer of 1994. Here (blue and red stripes) he was unable to save Barcelona from a 4–0 defeat by Italy's AC Milan in the Champions League Final in Athens in May. In early July, however, he was top scorer when Brazil beat Italy in the World Cup Final in Pasadena.

"I'm a man who likes being around other people. I like going dancing, seeing my friends. Ideally, I'd go out every night except, of course, the night before a match."

Romario, during his Barcelona days

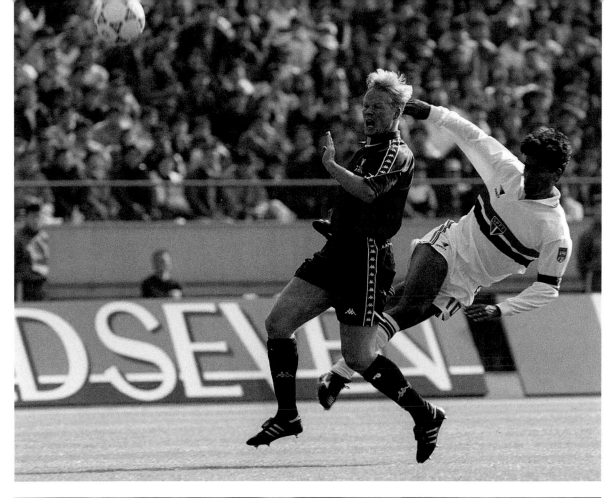

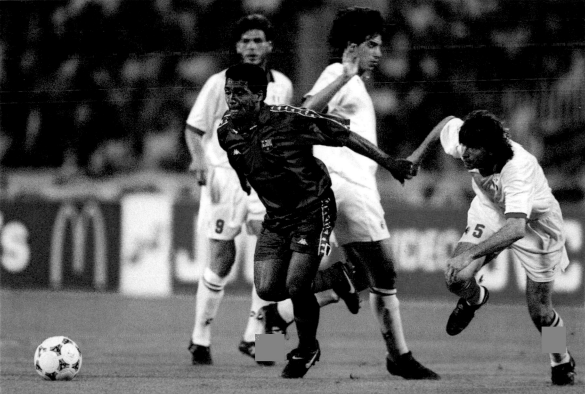

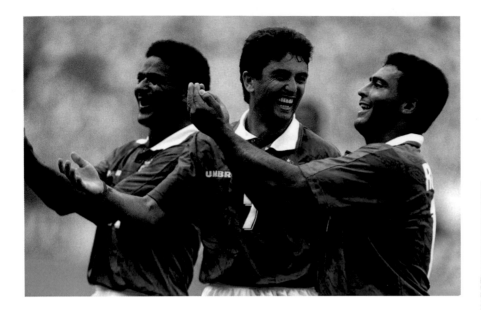

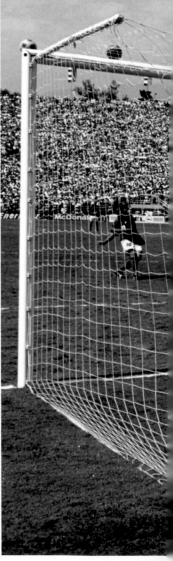

Against that backdrop of angst elsewhere, Brazil sailed serenely through. Russia and Cameroon were beaten 2–0 and 3–0 respectively and Romario was on target for a third successive game in a 1–1 draw against an impressive Sweden team.

Bebeto scored the goal which knocked out Brazil's US hosts in the second round and then the second in a 3–2 quarter-final victory over Holland. He marked the moment, famously, with his rock-the-cradle celebration in honour of his newly-born son Matheus back home. Romario dispatched Sweden in the semi-final in Pasadena.

This set up a dream final between Brazil and Italy, the two nations who had both, by now, won the World Cup three times; and with Romario matched against Roberto Baggio, the other outstanding individual at the finals. Brazil had the advantage of already being in California, while Italy effectively lost a day in having to fly coast to coast after their semi-final defeat of Bulgaria in New Jersey.

The final was awful, whether because of the pressure or the heat. Even half-chances of a goal were few and far between. Thus normal time and extra time ended goalless and the World Cup Final was decided, for the first time in its history, by the lottery of a penalty shoot-out.

Brazilian hearts were in their mouths when Marcio Santos missed the first kick; then so did Italy's Franco Baresi. Romario, left-back Branco and Dunga all scored. So did Demetrio Albertini and Alberigo Evani, but not Daniele Massaro and not Baggio.

Brazil, World Cup winners for a record fourth time, duly dedicated their success to the memory of Ayrton Senna, the Formula One motor racing champion who had been killed in a crash at Imola on May 1.

OPPOSITE: Mazinho (left) and Romario (right) join marksman Bebeto in a special celebration after he had scored Brazil's second goal in their World Cup quarter-final defeat of Holland in 1994. Bebeto devised his "rock the baby" celebration to mark the birth of a baby son. Years later he returned to the World Cup as a member of Brazil's 2014 organizing committee.

BELOW: Roberto Baggio lofts the decisive penalty over both goalkeeper Claudio Taffarel and the bar to present Brazil with their fourth World Cup in 1994. This was the first final to be decided by a shoot-out. Some 12 years later Italy's luck changed when they beat France in a shoot-out after extra time in the 2006 World Cup Final in Berlin.

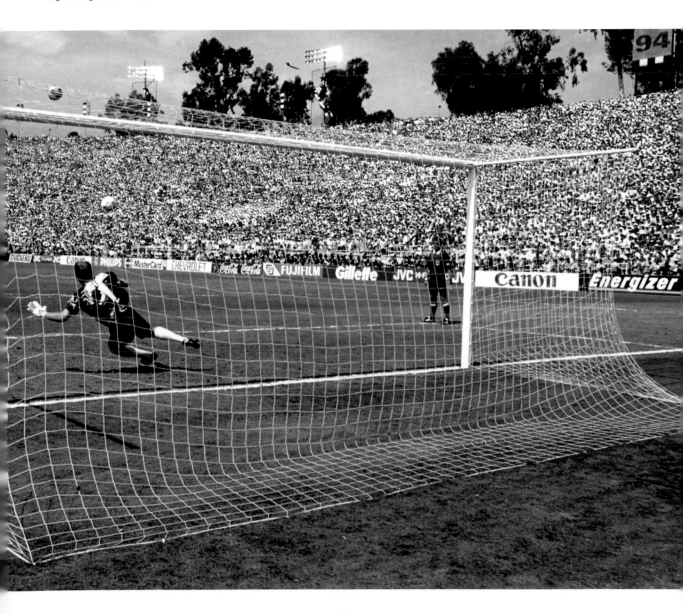

The teenager Ronaldo never even enjoyed a minute on the pitch as a substitute during those finals. But four years later, in France, he had taken over from a disgruntled, dropped Romario as cock of the goalscoring walk.

For a while Ronaldo would follow in Romario's footsteps. Immediately after the 1994 finals Ronaldo was sold by Cruzeiro of Belo Horizonte to PSV Eindhoven and then he went on to Barcelona. He scored goals at the rate of almost one per game and had moved to Italy's Internazionale – helping them win the UEFA Cup in his first season – by the time the 1998 World Cup came around.

Veteran coach Zagallo, an aide to Parreira in 1994, was now restored as coach. As in 1974, he had to make the best of a fragmenting squad by introducing new stars such as attacking left-back Roberto Carlos and languid forward Rivaldo. Above all, Zagallo had Ronaldo as his trump card.

By now "O (or El or Il) Fenomeno" was the world's leading player. He boasted two FIFA awards to prove it, plus France Football's European Footballer of the Year title. He had top-scored in Holland and Spain and had won domestic and international club trophies in both countries as well as Italy.

In Group A Ronaldo scored only once, in a 3–0 win over Morocco. Brazil still topped the table, though they struggled at times in a 2–1 opening win over Scotland and lost the last game by the same margin to Norway.

This was not quite the plan. Off the pitch Ronaldo had other concerns, with the very public fragmenting of his relationship with girlfriend Suzanna Werner.

Ronaldo appeared to set aside both this fuss and an irritating knee problem for the knockout stages. He scored twice against Chile in the second round and played a key role, despite not finding the net, in the 3–2 quarter-final defeat of Denmark. He scored his fourth goal of the finals against Holland in the semi-finals and converted Brazil's first penalty to set them on their way to a nerve-shredding shoot-out success.

Holders Brazil against hosts France in the new Stade de France was the perfect final. But not for Ronaldo. He had been treated with painkilling and anti-inflammatory drugs for the problem with his left knee, but trained as usual with the squad on the morning of the final.

The squad returned to rest at their hotel where room-mate Roberto Carlos raised the alarm after witnessing Ronaldo undergoing an apparent fit. After he had apparently recovered and been sent to bed to sleep, the medical and coaching staff met. Zagallo decided to hold back Ronaldo on the subs' bench and start with the Fiorentina forward Edmundo.

At Teixeira's insistence Ronaldo was sent to the World Cup clinic for a check-up while the rest of the team travelled to the stadium. When the time came to hand in Brazil's teamsheet Zagallo wrote down the name of Edmundo. Within minutes the teamsheet had been registered by Moroccan referee Said Belqola and issued to the media.

ABOVE: French players enjoy the taste of success at the 1998 World Cup Final after outplaying Brazil 3–0 in the Stade de France in Paris. Ronaldo (left) was a shadow of his normal self after having been taken ill before the match. Only weeks earlier, also in Paris but in the Parc des Princes, he had been a winner with Italy's Internazionale in the UEFA Cup Final.

RIGHT: Roberto Carlos was one of Brazil's most popular players in the 1990s with his dramatic raids from left-back and his thunderous free-kicks from any distance. But a loser's medal was not the prize Ronaldo's room-mate had expected to collect at the end of the 1998 World Cup Final. It was Roberto Carlos who had raised the alarm after Ronaldo fell ill.

Just as the shock team news was being broadcast around the world, Ronaldo and medical chief Lidio Toledo walked into the dressing-room. The medical report gave him a clean bill of health.

What happened next remains open to question. Beyond doubt is the fact that the Brazilians asked, and were granted, permission to make a late change and reinstate Ronaldo in the team. Volunteers ran around the media areas trying to retrieve and replace the original teamsheets.

Ronaldo duly played, or rather he appeared on the pitch, for the full 90 minutes but contributed nothing to a game which France won decisively and deservedly by a 3–0 scoreline.

Speculation was rife later that Zagallo had been reluctant to pick Ronaldo but had been pressured by Teixeira and by team sponsor Nike. Zagallo, Teixeira and Nike spokesmen all denied such talk. Zagallo's only concession to misjudgement was that he spent much of the match wondering whether to take Ronaldo off.

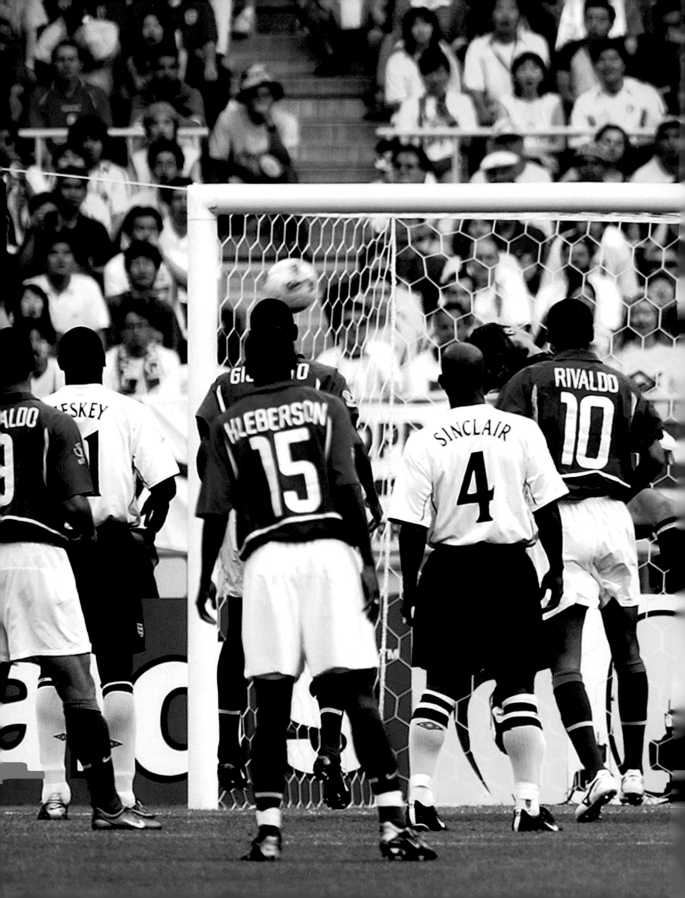

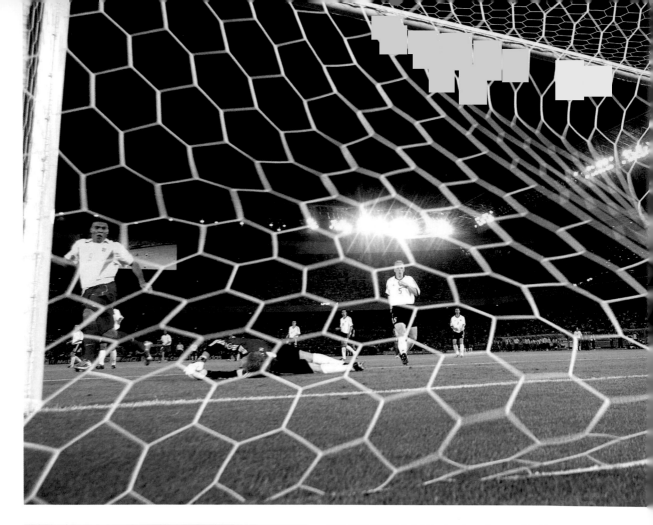

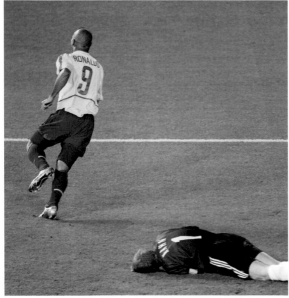

PREVIOUS PAGE: England goalkeeper David Seaman turns in disbelief to find that a long, looping free-kick from Brazil's Ronaldinho has eluded him and dropped into the net. Ronaldinho's amazing strike out of the blue put Brazil 2–1 ahead in their 2002 quarter-final in Japan. They held on to reach the semi-finals even though Ronaldinho was subsequently sent off.

ABOVE AND LEFT: The net bulges as Ronaldo scores the decisive second goal for Brazil against Germany in the 2002 World Cup Final then (left) turns away in delight. Ronaldo's two goals in the match established him as the tournament's leading scorer with eight goals – a remarkable return to the pinnacle of the game for him after four injury-scarred years.

No one present at the chaotic post-final press conference would have dared dream that, four years later, Ronaldo's World Cup reputation would have turned upside down. In 2002, in the first-ever co-hosted World Cup in Japan and South Korea, Brazil won their record-extending fifth title after a 2–0 victory over Germany in Yokohama.

Brazil, this time, had raced through to the final, scattering Turkey, China, Costa Rica, Belgium, England and Turkey again along their route into history. Ronaldo was leading scorer with eight goals, including both in the final. His triumph was all the more incredible because, on top of having to recover from the mental scars of 1998, he had spent much of the intervening four years sidelined by knee trouble.

In Luiz Felipe Scolari, a wily coach with a talent for inspiring players and fans alike, Ronaldo had found just the man to bring the best out of the team around him. So it was unfortunate that Scolari could not be persuaded to stay. Instead he headed off to coach Portugal, and took them to the semi-finals of the 2006 World Cup in Germany where Brazil fell in the quarter-finals to France. Ronaldo's three goals turned him into the most prolific World Cup finals marksman of all time, with a total of 15 in the three tournaments he played.

The weight problems which had proved increasingly troublesome in his career meant he was far from his best, and this time the roller-coaster of fame and fortune thrust him back down into the depths of recriminations from the fans back home.

RIGHT: France proved jinx opponents for Brazil at the World Cup finals in 1986, 1998 and again in 2006 in Germany. The latter clash ended with Zinedine Zidane (right) applauding a 1–0 victory, while the grounded Ze Roberto cannot hide his dismay in defeat. Zidane, who scored twice against Brazil in the 1998 final, was also man of the match in 2006 in Frankfurt.

LEFT: Dunga came close to matching the unique achievement of Franz Beckenbauer, who both captained and managed West Germany to World Cup victory (in 1974 and 1990). The hard-tackling midfielder captained Brazil to victory in 1994 in the United States, but his stint as manager ended in defeat by Holland in the quarter-finals in South Africa in 2010.

OPPOSITE: Robinho and Andre Santos celebrate Brazil's victory over the United States in the final of the "warm-up" Confederations Cup at Ellis Park, Johannesburg, in 2009. They considered victory a happy omen one year ahead of their return for the World Cup finals. Brazil hit back to beat the Americans 3–2 after going 2–0 down inside the first 27 minutes.

Carlos Alberto Parreira, who had returned to the stresses of Selecao management against his own better judgement, paid the price of failure with his job. Reaching the quarter-finals might have been comparative success for other nations, but not for Brazil.

Dunga, former captain, found out that same painful truth when "his" Brazil were also knocked out at the last eight stage in South Africa in 2010 by Holland. Victory in Johannesburg the previous year in the Confederations Cup meant nothing after the main prize proved beyond reach.

The one consolatory thought was that, next time around, Brazil would be odds-on favourites as host nation.

CBF president Teixeira, controversial as ever but all-powerful, had ambitions of his own to follow where Havelange had led. He had become president of the CBF in 1989 and been voted on to the governing executive committee of world federation FIFA in 1994 as one of three delegates from CONMEBOL (Confederacion Sudamericana de Futbol), the South American confederation.

Inevitably, it appeared to FIFA watchers in Zurich, Teixeira would seek the presidency for himself. Securing Brazil's status at the heart of the international game was essential. The perfect opportunity arose when incumbent president Sepp Blatter decided the World Cup finals should go to Africa for the first time and, more particularly, to Nelson Mandela's South Africa.

❝Brazil goes into every World Cup expecting to win – so when it is in Brazil it is expected even more. You can't understand what the World Cup means to our country.❞ *Ronaldinho*

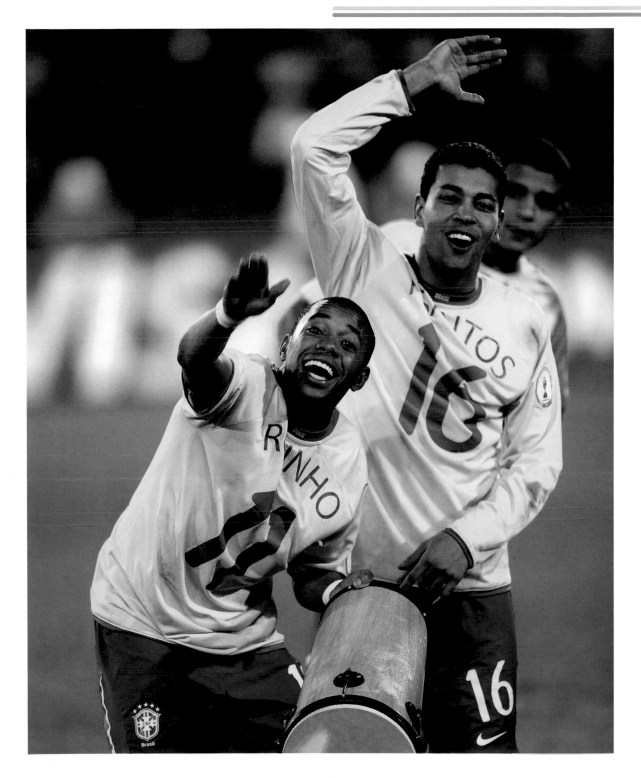

LEFT: Midfielder Gilberto Silva in evident dismay after Brazil's defeat at the hands of Holland in the 2010 World Cup quarter-finals in the Nelson Mandela Bay Stadium in Port Elizabeth, South Africa. He knew, from previous such defeats, that the players would be greeted with anger and derision on their return home and that the inquest would last for months.

OPPOSITE: Ricardo Teixeira, at the time of the qualifying draw for the 2014 World Cup, was the all-powerful president of both the organizing committee and of the Brazilian football confederation. He was also a senior member of FIFA's executive committee. Within two years he was out of a job, after fleeing to Miami to escape pressure from a string of commercial scandals.

Achieving such an award meant FIFA adopting (temporarily and purposefully) a system of "rotation" between the continents. Asia had hosted the finals in 2002, Europe in 2006, Africa would have its 2010 finals and thus South America, theoretically, was due 2014. Economically, only Brazil was in a position to lodge a bid by the deadline of October 2007.

Early that year Teixeira brought over to Brazil Jerome Valcke, who had headed up FIFA's marketing division until the end of 2006. The Frenchman had then been sent on "gardening leave" after an acrimonious court case in New York which followed FIFA's replacement of long-term sponsor MasterCard with Visa.

Valcke spent three months in Brazil, effectively at Teixeira's behest, preparing the CBF's World Cup hosting bid. The bid had the full support of President Luiz Inacio Lula da Silva and offered to fulfil without question all the complex guarantees demanded of a host nation. No other country chose to bid, not Argentina, not Chile, not Colombia: on October 30, 2007, and by a walkover, Brazil was awarded the right, the privilege, the honour of staging the 2014 World Cup (and the preparatory 2013 Confederations Cup).

> **❝The World Cup is all on schedule. I'm not worried. It'll all turn out fine . . . money makes the world go round.❞** *Ricardo Teixeira, then president of the CBF, in 2011*

Lula professed himself delighted. After all, no fewer than six host nations had won the World Cup in the past: surely Brazil would convert that into seven and make amends for 1950?

But winning host rights and undertaking all the work necessary are two entirely different issues. Brazil had taken on a massive task in terms of rebuilding all its main stadia, modernizing and expanding all its airports and creating a vast new network of roads, rail links and hotels for the anticipated thousands of visiting fans.

Soon problems became evident. Financing the infrastructure development demanded complex negotiations, often bogged down by the need for political approvals at federal, state and city government levels. Decision-making was delayed by elections which saw, among other changes, Dilma Rousseff elected to succeed Lula.

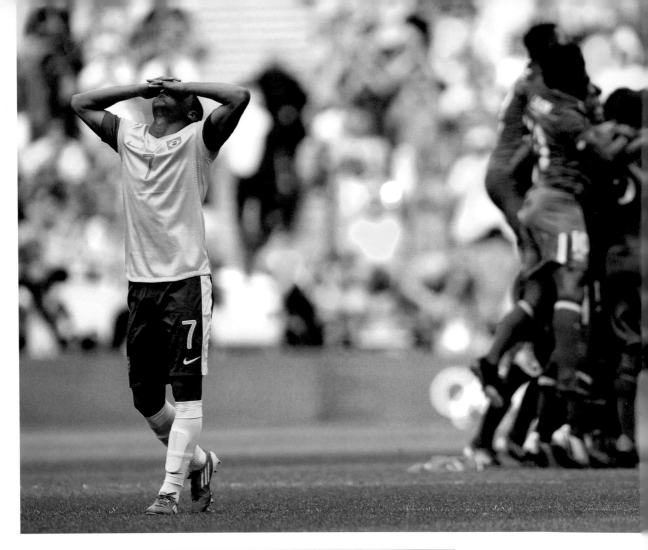

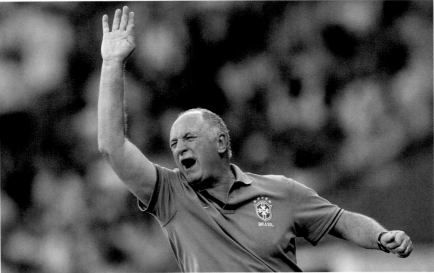

LEFT: Luiz Felipe Scolari drove Brazil to World Cup victory in 2002. He was then recalled in November 2009 to try to repeat the trick under even greater pressure, as manager of the host nation at the 2014 World Cup. Scolari – nicknamed Felipao ("Big Phil") – enjoyed immediate success as his "new" Brazil defeated Spain to win the Confederations Cup (a sort of World Cup dress-rehearsal) in 2013.

ABOVE: Brazil's Lucas Moura cannot believe it after favourites Brazil lose 2–1 to Mexico at the final of the London 2012 Olympic football tournament. Olympic gold is the one international prize Brazil have never won, and defeat at Wembley hastened the dismissal of coach Mano Menezes. Brazil will be favourites to make amends when they line up as hosts at Rio 2016.

Four years after the go-ahead, in October 2011, FIFA and the Brazilian local organizing committee unveiled the calendar for the finals. An expensive blow to foreign fans in a world of austerity was a decision to scrap the original plan of using "venue clusters" to ease travel stresses between the 12 cities.

By now Valcke, author of the bid, had returned to FIFA as its powerful secretary-general. He had also taken on the mantle of overall World Cup director and progress-chaser. No one knew the bid better and no one within FIFA had a better understanding of how best to work with the Brazilians.

As the finals drew closer, so concerns grew about the pace of preparations. But the confidence of the Brazilian organizing committee – who include Ronaldo and Bebeto – was apparently vindicated when the Confederations Cup warm-up tournament went ahead, as planned, in the summer of 2013.

Meanwhile, back in the football sphere, the CBF had other concerns. In 2010 Mano Menezes was removed from Corinthians and appointed by Teixeira to boss the Selecao. His task was clear: to take Brazil through to the World Cup finals he had first to win Olympic gold in London, then put up a bravura showing at the Confederations Cup.

Curiously, Brazil have never won the Olympic football tournament. Olympic football success is not a high-level target for many of the world's football giants. But its significance for Brazil was powered by perpetual failure. Twice they had won silver and twice bronze. But never gold.

Olympic football is an under-23 tournament but each nation may pick three over-age players. Menezes picked a powerful squad with a majority of the players likely to represent Brazil at the World Cup. These included defenders Thiago Silva and Marcelo, midfielders Leandro Damiao and Oscar, plus forwards Neymar and Hulk. Neymar, from Pele's old club Santos, was the new superstar. At only 20 he had been hailed already as South American Footballer of the Year.

Unfortunately and surprisingly, Brazil came unstuck by 2–1 against Mexico in the gold medal match at Wembley. That was disasterous for Menezes, who was sacked and replaced by Scolari days before the draw for the Confederations Cup in Sao Paulo later in the year.

Scolari, World Cup-winning boss in 2002, set himself two targets. One was to build a team which could be competitive at the Confederations Cup and be a serious contender to win the World Cup; the other was to re-connect the Selecao with Brazilian fans increasingly impatient with the players, whose lifestyles were beyond their wildest dreams.

Ironically, when popular unrest did burst across Brazil just before the Confederations Cup it was sparked by a bus fare increase in Sao Paulo. Within days the launch of the tournament, with all the attendant publicity about the costs involved, had poured fuel on the fire of popular disquiet.

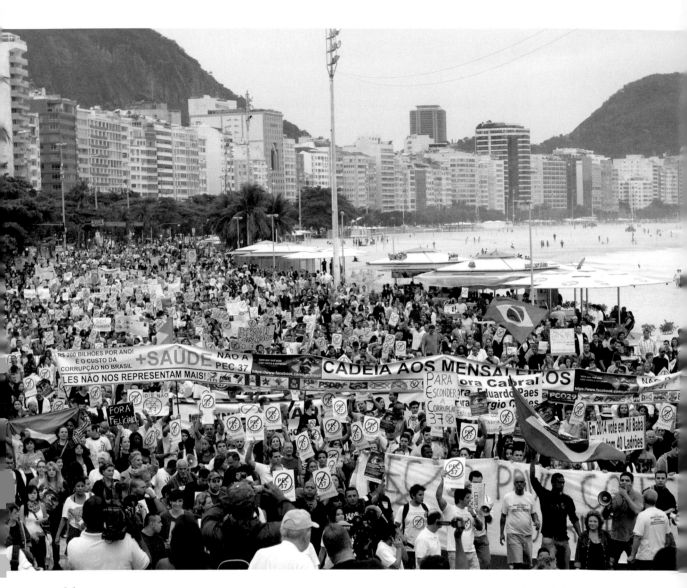

"We need to be strong in every sense of the word in Brazil, not only in football but in all the other details." *Luiz Felipe Scolari, World Cup winning coach, on Brazil's World Cup challenge*

ABOVE: Street protests come to Copacabana beach in Rio during the 2013 Confederations Cup. A wave of demonstrations flooded across Brazil during the tournament as millions complained about a perceived imbalance between the government's expenditure on social welfare and the costs of preparing for the World Cup finals.

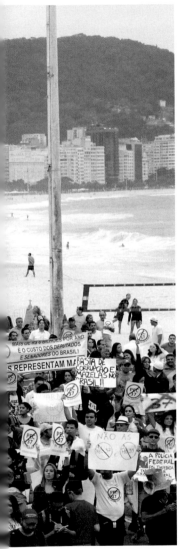

Suddenly protest marches were erupting all over Brazil with hundreds of thousands – if not millions – on the march. Rousseff's government, the military police and FIFA were all caught on the back foot by a popular rising out of nowhere.

Initially the protests were reported as targeting FIFA and the World Cup. But that was simplistic. Brazil was a country with a fast-growing middle class. The associated educational improvements teach people to think for themselves and ditch blind acceptance of the old stereotypes of society.

For the first time in the two decades since the return to democratic rule the streets were alive with demands for more to be done, and at a far greater speed, to improve living standards.

The World Cup and its costs had provided a standard by which social welfare spending was judged to be insufficient. In vain did Sports Minister Aldo Rebelo protest that the stadia were financed by private finance or state loans and that it all added up to a drop in the ocean compared with the national social welfare budget.

As the Confederations Cup matches began, entertainingly, attractively and safely, so Rousseff responded to the street protests with promises of a plebiscite for political reform and tighter anti-corruption legislation.

RIGHT: Presidents Sepp Blatter of FIFA and Dilma Rousseff of Brazil were enjoying the atmosphere at the opening match of the 2013 Confederations Cup – until they were introduced to the crowd. Both were subjected to a storm of abuse by fans ahead of Brazil's match with Japan in Brasilia. Rousseff later decided not to attend the final to avoid a repetition.

Brazil's own players and managers trod a sensitively sympathetic path. They spoke out in approval of the right of the masses to march in peaceful protest, while disapproving of the hooligan violence which provoked some of the tear-gas-fuelled police response.

Ronaldo, derided for early naïve comments that football tournaments were built "with stadia not hospitals", soon changed his tune, saying: "I fully support the demonstrations because the Brazilian people were tired of the situation that we face.

"Walking around the streets and talking to people I realized that Brazilians are not against the World Cup or the Confederations Cup – Brazilians are against corruption, embezzlement and the way the health system has been managed and the education system has been managed.

"It's been wonderful to see Brazilians really rise up against this situation and to see that most demonstrations have been peacefully asking for change in Brazil. This has been very touching and we have already seen the results because things seem to be moving forward and the government seems to be responding to the people's calls."

The greatest irony of all is that the protests brought far greater worldwide visibility to the Confederations Cup than it has ever enjoyed in all of its previous 20 years of existence put together.

The final, in which the hosts trounced Spain 3–0, saw the Brazilian public in schizophrenic mood: thousands marched in protest outside Maracana, while 70,000 inside roared on their team. "Timinho, timinho (Little team, little team)!" they taunted Spain in derision before uniting in: "O campeao voltou (The champions are back)!" But that, after all, is Brazil ... football at the heart of the action.

> **"Neymar is a great Brazilian talent. He's a rare gem. Very focused, very disciplined. He's always aiming to score goals and win titles. There's nothing special I can tell him that he isn't already doing."** *Ronaldo's view on Neymar*

RECORDS

THE NATIONAL TEAM

THE WORLD CUP
Winners: 1958, 1962, 1970, 1994, 2002 (five); **Runners-up:** 1998; **Third place:** 1938, 1978; **Fourth:** 1974

1958 Solna, Stockholm (Sweden)
Brazil 5 Sweden 2
Goals: Vava 2, Pele 2, Zagallo
Team: Gilmar – Djalma Santos, Bellini, Orlando, Nilton Santos – Zito, Didi – Garrincha, Vava, Pele, Zagallo.
Coach: Feola

Squad:
Goalkeepers: Gilmar, Castilho
Defenders: Bellini, Djalma Santos, Nilton Santos, De Sordi, Orlando, Mauro
Midfield: Dino Sani, Didi, Oreco, Zozimo, Moacir, Zito
Forwards: Zagallo, Pele, Garrincha, Joel, Mazzola, Vava, Dida, Pepe.

1962 Santiago (Chile)
Brazil 3 Czechoslovakia 1
Goals: Amarildo, Zito, Vava
Team: Gilmar – Djalma Santos, Mauro, Zozimo, Nilton Santos – Zito, Didi, Zagallo – Garrincha, Vava, Amarildo.
Coach: Aimore Moreira

Squad:
Goalkeepers: Gilmar, Castilho
Defenders: Djalma Santos, Mauro, Zozimo, Nilton Santos, Jair Marinho, Bellini, Jurandir, Altair
Midfielders: Zito, Didi, Zequinha, Mengalvio, Zagallo
Forwards: Garrincha, Coutinho, Pele, Pepe, Jair da Costa, Vava, Amarildo

1970 Mexico City (Mexico)
Brazil 4 Italy 1
Goals: Pele, Gerson, Jairzinho, Carlos Alberto
Brazil: Felix – Carlos Alberto, Brito, Wilson Piazza, Everaldo – Gerson, Clodoaldo, Rivelino – Jairzinho, Tostao, Pele.
Coach: Zagallo

Squad:
Goalkeepers: Felix, Ado, Leao
Defenders: Brito, Wilson Piazza, Carlos Alberto, Marco Antonio, Baldocchi, Fontana, Everaldo, Joel, Ze Maria
Midfielders: Clodoaldo, Gerson, Rivelino, Paulo Cesar
Forwards: Jairzinho, Tostao, Pele, Roberto, Edu, Dario

1994 Pasadena (United States)
Brazil 0 Italy 0 after extra-time
Brazil 3–2 on penalties
Team: Taffarel – Jorginho (Cafu 21), Aldair, Marcio Santos, Branco – Zinho (Viola 106), Dunga, Mauro Silva, Mazinho – Romario, Bebeto.
Coach: Carlos Alberto Parreira

Squad:
Goalkeepers: Taffarel, Zetti, Gilmar Jr
Defenders: Jorginho, Ricardo Rocha, Ronaldao, Branco, Aldair, Cafu, Marcio Santos
Midfielders: Mauro Silva, Dunga, Zinho, Rai, Leonardo, Mazinho
Forwards: Bebeto, Romario, Paulo Sergio, Muller, Ronaldo, Viola

2002 Yokohama (Japan)
Brazil 2 Germany 0
Goals: Ronaldo 2
Brazil: Marcos – Cafu, Lucio, Roque Junior, Roberto Carlos – Edmilson, Gilberto Silva, Kleberson – Ronaldinho (Juninho Paulista 85), Ronaldo (Denilson 90), Rivaldo.
Coach: Luiz Felipe Scolari

Squad:
Goalkeepers: Marcos, Dida, Rogerio Ceni
Defenders: Cafu, Lucio, Roque Junior, Roberto Carlos, Juliano Belletti, Anderson Polga, Junior
Midfielders: Edmilson, Gilberto Silva, Ricardinho, Gilberto, Kleberson, Vampeta, Juninho, Kaka
Forwards: Ronaldo, Rivaldo, Ronaldinho, Denilson, Edilson, Luizao

FIFA U–20 WORLD CUP
Winners: five
1983 (Mexico): Brazil 1 Argentina 0
1985 (Soviet Union): Brazil 1 Spain 0 after extra time
1993 (Australia): Brazil 2 Ghana 1
2003 (UAE): Brazil 1 Spain 0

2011 (Colombia): Brazil 3 Portugal 2 after extra time

FIFA U–17 WORLD CUP
Winners: three
1997 (Egypt): Brazil 2 Ghana 1
1999 (New Zealand): Brazil 0 Australia 0 (8–7 on penalties)
2003 (Finland): Brazil 1 Spain 0

COPA AMERICA
Winners: eight
League system (host)
1919 (Brazil)
1922 (Brazil)
1949 (Brazil)

Knockout system (host)
1989 (Paraguay): Brazil 3 Uruguay 0
1997 (Bolivia): Brazil 3 Bolivia 1
1999 (Paraguay): Brazil 3 Uruguay 0
2004 (Peru): Brazil 2 Argentina 2 (4–2 on penalties)
2007 (Venezuela): Brazil 3 Argentina 0

CONFEDERATIONS CUP
Winners: four
1997 (Saudi Arabia): Brazil 6 Australia 0
2005 (Germany): Brazil 4 Argentina 1
2009 (South Africa): Brazil 3 United States 2
2013 (Brazil): Brazil 3 Spain 0

INDIVIDUAL RECORDS
Most international appearances
1 Cafu 142
2 Roberto Carlos 125
3 Lucio 105
4 Claudio Taffarel 101
5= Djalma Santos 98, Ronaldo 98, Ronaldinho 98
8 Gilmar 94
9 Gilberto Silva 93
10= Pele 92, Rivelino 92

Most international goals
1 Pele 77
2 Ronaldo 62
3 Romario 55
4 Zico 52
5 Bebeto 39
6 Rivaldo 34
7= Jairzinho 33, Ronaldinho 33
9= Ademir 32, Tostao 32

BEACH WORLD CUP FINALS

1995 (Copacabana, Rio/Brazil):
Brazil 8 USA 1
Top scorers: Zico (Brazil), Altobelli
(Italy) 12
1996 (Copacabana): Brazil 3 Uruguay 0
Top scorer: Altobelli (Italy) 14
1997 (Copacabana): Brazil 5 Uruguay 2
Top scorers: Junior (Brazil), Venancio
Ramos (Uruguay) 11
1998 (Copacabana): Brazil 9 France 2
Top scorer: Junior (Brazil) 14
1999 (Copacabana): Brazil 5 France 2
Top scorers: Junior (Brazil), Matosas
(Uruguay) 10
2000 (Marina da Gloria, Rio): Brazil 6
Peru 2
Top scorer: Junior (Brazil) 13
2001 (Costa do Sauipe, Rio): Portugal 9
France 3
Top scorer: Alan (Portugal) 10
2002 (Vitoria, Brazil): Brazil 6
Portugal 5
Top scorers: Nenem (Brazil), Madjer
(Portugal), Nico (Uruguay) 9
2003 (Copacabana): Brazil 8 Spain 2
Top scorer: Nemem (Brazil) 15
2004 (Copacabana): Brazil 6 Spain 4
Top scorer: Madjer (Portugal) 12
2005 (Copacabana): France 3 Portugal 3
(France win 1–0 on penalties)
Top scorer: Madjer (Portugal) 12
2006 (Copacabana): Brazil 4 Uruguay 1
Top scorer: Madjer (Portugal) 21
2007 (Copacabana): Brazil 8 Mexico 2
Top scorer: Buru (Brazil) 10
2008 (Plage du Pardo, Marseille/
France): Brazil 5 Italy 3
Top scorer: Madjer (Portugal) 13
2009 (Jumeirah Beach/Dubai):
Brazil 10 Switzerland 5
Top scorer: Stankovic (Switzerland) 16
2011 (Marina di Ravenna/Italy):
Russia 12 Brazil 8
Top scorer: Andre (Brazil) 14

CLUBS – INTERNATIONAL

FIFA CLUB WORLD CUP
(incorporating former Intercontinental
Club Cup aka 'World Club Cup'):
Sao Paulo three (1992, 1993, 2005);
Corinthians two (2000, 2012), Santos
two (1962, 1963); Flamengo (1981),
Gremio (1983), Internacional (2006)

As Intercontinental Club Cup:
1962: Santos bt Benfica (Por) 3–2, 5–2
(7–4 on agg)
1963: Santos bt Milan (It) 2–4, 4–2, 1–0
(play-off)
1981 (Tokyo): Flamengo 3 Liverpool
(Eng) 0
1983 (Tokyo): Gremio 2 Hamburg
(Ger) 1
1992 (Tokyo): Sao Paulo 2 Barcelona
(Sp) 1
1993 (Tokyo): Sao Paulo 3 Milan
(It) 2

As FIFA Club World Cup:
2000 (in Brazil): Corinthians 0 Vasco
da Gama (Brz) 0 (4-3 on penalties)
2005 (Tokyo): Sao Paulo 1 Liverpool
(Eng) 0
2006 (Tokyo): Internacional 1
Barcelona (Sp) 0
2012 (Tokyo): Corinthians 1 Chelsea
(Eng) 0

COPA LIBERTADORES
Sao Paulo three (1992, 1993, 2005),
Santos three (1962, 1963, 2011);
Cruzeiro two (1976, 1997), Gremio
two (1983, 1995), Internacional two
(2006, 2010); Atletico Mineiro (2013),
Corinthians (2012), Flamengo (1981),
Palmeiras (1999), Vasco da Gama (1998),

CLUBS – NATIONAL AND STATE CHAMPIONSHIPS

CAMPEONATO BRASILEIRO
(including incorporation of the Taca
Brasil 1959–68 and Torneio Roberto
Gomes Pedrosa 1967–70):
Santos 8, Palmeiras 8; Sao Paulo 6;
Corinthians 5, Flamengo 5; Vasco
da Gama 4, Fluminense 4;
Internacional 3; Cruzeiro 2,
Botafogo 2, Grêmio 2, Bahia 2;
Atletico Mineiro 1, Guarani 1,
Atletico Paranaense 1, Coritiba 1,
Sport Recife 1

RIO DE JANEIRO
(Carioca, from 1906):
Flamengo 32, Fluminense 31,
Vasco da Gama 22, Botafogo 20,
America 7, Bangu 2, Sao Cristovao 1,
Paysandu 1

SAO PAULO
(Paulista, from 1902):
Corinthians 27, Palmeiras 22, Sao
Paulo 21, Santos 20, Paulistano 11,
Sao Paulo Athletic 4, Portuguesa 3,
A A das Palmeiras 3, Germania 2,
Americano 2, Internacional SP 2,
Sao Bento 2, Sao Caetano 1, Ituano 1,
Bragantino 1, Inter de Limeira 1

MINAS GERAIS
(Mineiro, from 1915):
Atletico Mineiro 42, Cruzeiro 35,
America 15, Nova Lima 5, Sabara 2,
Ipatinga 1, Pocos de Caldas 1

PARANA
(Paranaense, from 1915):
Coritiba 37, Atletico Paranaense 22,
Ferroviario 8, Parana 7, Britania 7,
Gremio Maringa 3, Londrina 3,
Palestra Italia 3, Pinheiros 2,
Colorado 1, Internacional 1, Parana 1,
Paranavai 1, Agua Verde 1, America 1,
Cascavel 1, Comercial 1, Iraty 1,
Monte Alegre 1

PERNAMBUCO
(Pernambucano from 1915):
Sport Recife 39, Santa Cruz 27,
Nautico 21, America 6, Torre Recife 3,
Tramways 2, Flamengo Recife 1

RIO GRANDE DO SUL
(from 1919):
Internacional 42, Gremio 36,
Guaramy de Bage 2, Juventude 1,
Bage 1, Pelotas Bandeira 1, Brasil de
Pelotas 1, Rio-Grandense-RG 1,
Farroupilha 1, Regimento da
Infantaria 1, Gremio Santanense 1,
Caxias 1, Rio Grande 1,
Americano-RS 1, Cruzeiro-RS 1,
Renner 1, Sao Paulo-RS 1

INDEX

PICTURE CREDITS

The publishers would like to thank the following sources for their kind permission to reproduce the pictures in this book.

Action Images: /Nick Kidd/Sporting Pictures: 130; /Pilar Olivares/Reuters: 114-115

Colorsport: 71, 81; /Tomikoshi: 80

Corbis: /Carlos Bippus/National Geographic Society: 15T

Getty Images: /AFP: 9, 12-13, 14-15B, 32-33, 62, 63, 64BL, 64-65, 84-85, 102, 105, 112, 141; /Vanderlei Almeida/ AFP: 58-59, 122, 131, 146BL; /Shaun Botterill: 113B; / David Cannon: 4BR, 82, 128; /Yasuyoshi Chiba/AFP: 148-149; /Chris Cole: 134TL; /Felipe Dana/FotoArena/ LatinContent: 94; /Tony Duffy: 70B; /Julian Finney: 107; /Carmen Flores/LatinContent: 52; /Stuart Franklin: 118-119, 146T; /Laurence Griffiths: 113T; /Alexandre Guzanshe/FotoArena/LatinContent: 91T, 91B; /Haynes Archive/Popperfoto: 23; /Mike Hewitt: 144; /Keystone: 42-43; /Keystone-France/Gamma-Keystone: 22BL, 35, 54, 55, 56-57; /Ross Kinnaird: 138-139; /Philippe Le Tellier/Paris Match Archive: 34T; /Mauricio Lima/AFP: 60B; /Alex Livesey: 90, 124, 126-127; /Douglas Magno/LatinContent: 89; /Ronald Martinez: 150-151; /Leonard McCombe/Time & Life Pictures: 56TL; /Jamie McDonald: 143; /Buda Mendes: 149; /Marcos Mendes/FotoArena/LatinContent: 104; /Damien Meyer/AFP: 140T, 140B; /Jeff Mitchell: 142; /Popperfoto: 22T, 25, 30, 31, 32TL, 34B, 36-37, 39TL, 40, 41, 44TL, 96, 97, 98TL, 98-99, 101, 136-137; /David Ramos: 153; /Michael Regan: 3C, 6-7, 120T, 120B, 145; /Robert Riger: 70T; /Rolls Press/Popperfoto: 47B, 48-49, 50-51, 51TR; /Wesley Santos/FotoArena/LatinContent: 93; / Antonio Scorza/AFP: 3R, 59R, 60T, 92, 108B, 116, 117; / Christophe Simon/AFP: 108T; /Paul Slade/Paris Match Archive: 68-69B; /Henri Szwarc/Bongarts: 134-135; /Bob Thomas: 67, 72TL, 74-75, 76, 77, 78-79, 83, 133B, 137TR; / Bob Thomas/Popperfoto: 5TL, 16, 19T, 19BR, 26, 29; /Rudy Trindade/NewsFree/LatinContent: 5R, 86; /VI Images: 68-69T; /Andre Vieira/MCT: 110-111; /Toru Yamanaka/ AFP: 133T

Offside Sports Photography: /Brainpix: 100; /L'Equipe: 20, 38-39B; /John Varley: 4L, 29

Press Association Images: /AP: 88; /Felipe Dana/AP: 125; /Derek Millward: 44-45; /Peter Robinson: 72-73, 95; /Sven Simon: 3L

Rex Features: /Aflo: 109; /Stuart Clarke: 10; /The World of Sports: 47TL

Wiki Commons: 11, 12TL

Every effort has been made to acknowledge correctly and contact the source and/or copyright holder of each picture and Carlton Books Limited apologises for any unintentional errors or omissions, which will be corrected in future editions of this book.